SECRET WARWICK

Graham Sutherland

AMBERLEY

First published 2022

Amberley Publishing
The Hill, Stroud
Gloucestershire, GL5 4EP

www.amberley-books.com

Copyright © Graham Sutherland, 2022

The right of Graham Sutherland to be identified
as the Author of this work has been asserted in
accordance with the Copyrights, Designs and Patents
Act 1988.

ISBN 978 1 3981 1176 9 (print)
ISBN 978 1 3981 1177 6 (ebook)

British Library Cataloguing in Publication Data.
A catalogue record for this book is available from the
British Library.

Origination by Amberley Publishing.
Printed in Great Britain.

Contents

Introduction

A hill town, albeit not very high, Warwick was a defensive position. The original name Waeringwic meant a settlement by a weir. There was no South Gate, this approach being protected by the River Avon. Only the East and West gates remain.

Three events shaped Warwick's history. The first occurred in AD 914, when Ethelfleda arrived. Eldest daughter of Alfred the Great, she tackled the problems caused by the Danes, and extended the fortified settlements, including Warwick, begun by him, and began building the castle and town. Unfortunately, celebrating Warwick's 1,000 years in 1914 could not happen because of the First World War, and was left until 2014. Her plaque is situated in Castle Street on the wall that was once entrances to public conveniences.

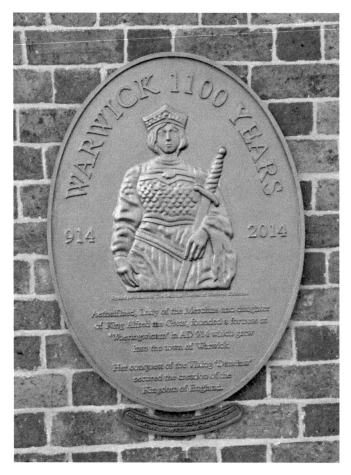

Ethelfleda Memorial plaque.

The second occurred in 1694 when Warwick was ravaged by a great fire, which resulted in the rebuilding of today's elegant town. The passage running alongside Oken's House, in Castle Street, gives a good impression of what Warwick's pre-fire streets were like. Effectively narrow wind tunnels, they aggravated an existing fire risk with naked flames and thatched rooves. Post-1945, Sir Patrick Abercrombie's plan for redeveloping Warwick recommended demolishing anything old, including the post-fire buildings. Fortunately, these plans were rejected.

The third involved Earls of Warwick (hereinafter referred to as the earl(s)) annexing various parts of the town between 1744 and 1800. They and the castle are mentioned only if appropriate as their history does not form part of this narrative. Today (2022) the castle is owned by Merlin Entertainments Group and is a major tourist attraction in the UK.

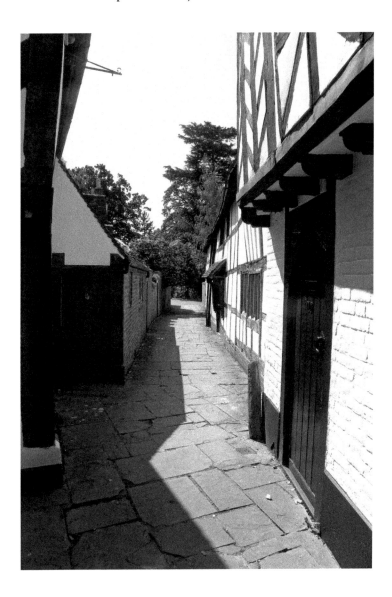

Oken's Passage.

1. Law and Order

Despite being the county town, Warwick has no law courts, police or fire stations, which are now based in neighbouring Royal Leamington Spa. Warwick was once a major centre for dealing with legal matters, which included Birmingham, and had its own prison until 1916.

Unlike other parts of Europe, England did not have any professional police until the late eighteenth century. All other places in England, except London, maintained law and order in a very haphazard way. Warwick operated the old parish constable system, now referred to as ward constables, who were supplemented by night watchmen of varying abilities. It was an unpaid, unpopular but obligatory duty and often farmed out to substitutes. Other parish officers, such as beadles, included peacekeeping amongst their duties. In time they were overseen by a single professional constable, Thomas Bellerby.

Self-appointed informants made precarious livings by reporting offenders for any offences they discovered. These included incorrect weights, measures and sending post other than by the official service. The informants shared the fines charged and were most unpopular. If discovered, they received little mercy, as one discovered in February 1824. He had reported a tradesman for issuing a receipt that was not on stamped paper. The crowd become so angry, the constable put him into a chaise and drove him out of town, but not until he had 'received all the embellishments which ingenuity could suggest and rotten eggs and dirt bestow' [sic].

A private police force, known as the Warwick Association for the Prosecution of Felons, protected its members for a fee. It was effective, but only for the privileged few. Although Leamington had employed a professional police force of sorts for several years, Warwick opposed the idea for various reasons, mainly money. Some associations still exist today, albeit only for social activities. Warwick's has been disbanded.

After what was described as 'Nightly Depredations', the council agreed on 5 December 1819, to set up watchmen to protect the seven wards in town, during the winter months. They were provided with greatcoats rattles, lanterns and candles for use whilst so employed. The watchmen reported for duty five days later, working 8 p.m. to 5 a.m.

Attitudes changed very slowly after Robert Peel's Metropolitan Police took to the streets of London in 1829. It was an unpopular move, and suggestions towards spreading the idea to the rest of England met with serious opposition. Warwick resisted the demands of the Municipal Corporation Act 1835, instructing them to set up their own police, until 1846 when:

> At a Special Meeting of the Council at the Court House on Saturday 26th day of September 1846, it was resolved that the Police Force, as at present constituted, is inefficient and needs revision and amendment.

The Warwick Borough Police Force was born the same year and lasted until 1875, when it merged with the Warwickshire Constabulary. Thomas Bellerby became its superintendent, until failing health caused him to retire in 1851, being replaced by William Charles Hickling. When the force joined the Warwickshire Constabulary, Hickling became Sergeant-at-Mace for the town council until his death in 1886. The Watch Committee provided uniforms and equipment, but policemen bought their own boots. Cutlass drill was obligatory, and firearms were provided. PC Walters was reprimanded and reduced in rank for firing his revolver in January 1868 when the Fenians were at Warwick Gaol (see Crime & Punishment), claiming it was an accident. He resigned and later that year revolvers were withdrawn.

St Mary's Collegiate Church (hereinafter referred to St Mary's) churchyard is entered by iron gates, once lockable. In 1846, it was a popular place where the ladies of the town plied their trade and was locked at night. Town centre constables had keys so they could pass through it occasionally.

The first police station was in the Holloway where the building still stands, adjoining the Globe, before moving to the old Yeomanry Barracks in Barrack Street. In the mid-1960s it moved to the junction of Cape Road and Priory Road. It was a pleasant location, although its architectural style was not to everyone's taste. Access to the car park was via a card operated security barrier. When the author was stationed there, in the absence of a proper security card, any bank card did the trick. This building was replaced by a new medical centre in 2021.

St Mary's churchyard.

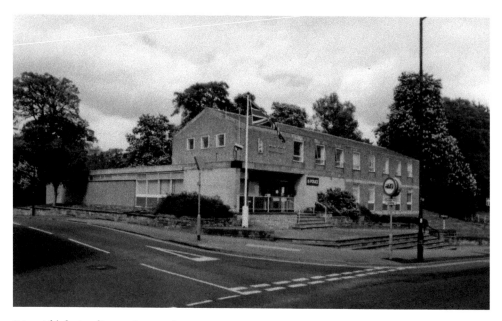

Warwick's last police station, 1996.

Opposite the old police station, and now private residences, the old Warwickshire Constabulary headquarters were opened in 1884. In 1929, Commander Edward Richard Busk Kemble became chief constable, when these ranks were only appointed from senior officers from the army or navy, and not the police. Kemble came from the Royal Navy, having fought at Jutland in 1916, but his career was seriously affected by sea sickness, and he resigned his commission. His police appointment caused much grief and upset within the constabulary. A rigid disciplinarian, he and his deputy, Herbert Scarborough Whitlock Wake, ran the constabulary with rods of iron. Wake was always known as 'he of the green ink' for obvious reasons. Kemble was the most controversial chief constable in the constabulary's history. A few days after retiring, Wake had his car totally trashed. Was this by aggrieved police officers extracting their revenge? No culprit was ever found.

Kemble was a complex character and a fanatic on road safety, insisting on drivers being persecuted, not prosecuted. With the formation of a traffic department in 1935, he did not set targets, but duty sergeants reported to him, before anyone could go off duty, how many drivers had been reported. If Kemble thought it was insufficient, they stayed until they had reported more. This persecution resulted in drivers being warned, nationally, to avoid Warwickshire if possible. Ironically, his only son was killed on a motorcycle during the Second World War.

The police ceased being a reserved occupation soon after 1939, and the shortfall meant using special constables and women. Kemble was against employing women, but had no alternative but to do so, although their conditions of service were very exacting. For example, only single women could apply, and should they marry, their resignation was automatic. After the war when asked his opinion about using women, he could not praise them enough!

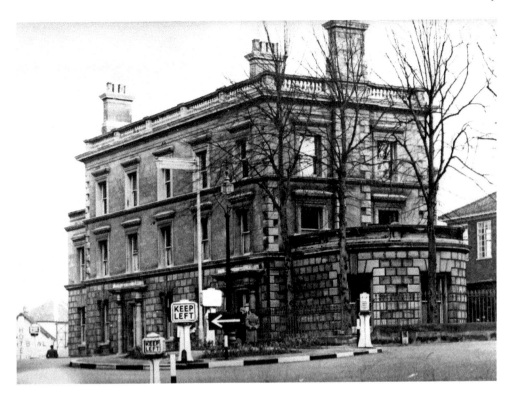

Old Police Headquarters.

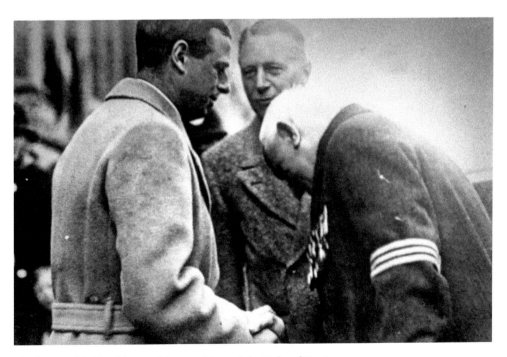

Chief Constable Kemble, special constable, and the Duke of Kent, 1934.

In the picture, the unidentified special constable wears his own clothes with only an armband to show he was on duty. Kemble is in the centre with the Duke of Kent on the left-hand side.

Kemble's chickens finally came home to roost in 1941, when he demoted an inspector and a sergeant for making a false verbal report concerning some property. Kemble's practice was to punish the offender and his immediate supervisor, for which they had no right of appeal. The demoted sergeant was transferred to Nuneaton, but immediately submitted his resignation, refusing to carry out any more police duties when Kemble declined to accept it.

He was charged with refusing to obey a lawful order, appeared at Warwick Magistrates' Court and fined 6d on each count. Furious, Kemble had him rearrested and recharged at Nuneaton court where he was fined 1s on each charge and finally permitted to resign. At this point, the Standing Joint Committee, who oversaw the police, intervened. They complained to the Home Office about the way the constabulary was run, likening it to a 'Gestapo State'. The author has tried to see a copy of the final report but was told there was no record of it! However, he discovered a press report that carried parts of it and was not surprised to see it was basically a 'whitewash', with Kemble being instructed to be less harsh in future.

Some police constables found their own revenge. Kemble's pride and joy at one stage, were the lawns at his house in nearby Ettington. One night when he was away, a disgruntled officer(s) went there, on the pretext of checking it was intact, and used the time to spread parsley seeds all over the lawns. The results were devastating. Kemble ordered a full enquiry with officers' clothing checked for seeds, but he never discovered who was responsible.

Gradually, Kemble's mind went, and he telephoned headquarters at odd times of the day and night, not knowing where he was. In 1948, he applied for a renewal of his contract, which would include moving to the new headquarters at Leek Wootton, but the Home Office declined. Later his gardener called the police to report Kemble had shot himself. He is buried at Ettington, in an unkempt grave.

Crime prevention was important and long gone is the post office in Old Square. This had a small piece of plain glass inserted in the opaque left-hand window, for passing policemen to check on the safe. In 1953, the post office in Smith Street mounted a crime prevention exhibition in its window.

In 2001, the Warwickshire Constabulary were renamed the Warwickshire Police. One suggested reason was to make it easier for foreign visitors to understand! It was costly as helmet plates, cap badges, numerous items of paperwork, vehicle livery etc all had to be changed.

The police were originally responsible for operating the fire engine, so bearing in mind the devastating fire of 1694, it is difficult to understand the Watch Committee's refusal to pay for oiling hoses and repairing broken lamps. Other problems involved rodents eating leather buckets and hoses, and corrosion issues. Someone was paid 5s (25p) to keep the water from freezing in the engine on frosty nights. If wells ran dry, bucket chains were used, which were ineffective but better than nothing. Prior to the Great Fire, Thomas

Right: Policeman's window.

Below: Crime prevention display, *c.* 1950s.

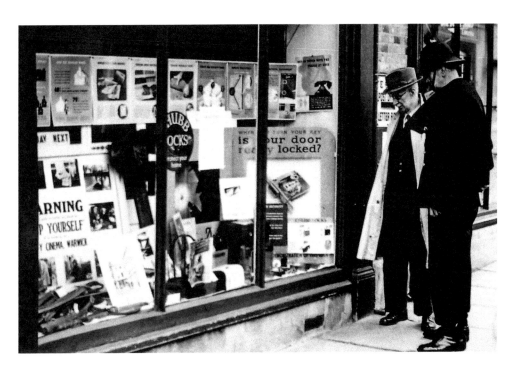

Oken's Charity provided twelve leather buckets at strategic locations for firefighting purposes. The court leet provided others. The illustration is a much later version, and the old buckets would have had handles.

Another problem arose when the first escape apparatus appeared. This was a collection of several extendable ladders. Where could they be housed? One suggestion was inside St Mary's, which was rejected on the grounds 'it would not do, as the people would be looking at the fire equipment and not the pastor'.

No specific horses were kept for the engine. When a fire happened, a policeman went to the Common and took the first two animals he found. One foggy night, the driver of the engine wondered why it would not steer straight. When unhitching the animals, he found a horse and cow harnessed together. Operating the manual pumps called for numerous volunteers.

Providing horses for the fire engine remained a problem until 1901, when the town council purchased two for this use. When not so employed, they were used on council carts until the first motorised engine arrived in 1927. The fire station was in the Butts for many years.

Above left: Leather bucket.

Above right: Old fire station, *c.* 1920.

2. Crime and Punishment

Crime

Frauds

Following the Great Fire, money was raised to help rebuild the town, resulting in the first of various problems. Many workmen had lost their tools in the blaze and needed new ones. A replacement scheme began, but all claims had to be submitted, on oath, within twenty-one days. The rebuilding was a honeypot for craftsmen, who flocked into the town with their reports and estimates. Figures were finally agreed and an Act of Parliament for rebuilding Warwick was passed, allowing two years for the project. William III visited in 1695, as seen in this picture from the 1906 Pageant. Twenty-six years later, claimants received compensation of 4s (20p) in the pound for their buildings and 1s 6d (7.5p) for their belongings. Was it fraud or incompetence?

The unthinkable happened in 1887, when the long established and highly respected Warwick and Warwickshire Bank went into receivership, causing heavy losses to many clients. The partners were George Greenway, then Warwick's town clerk, and his brother Kelynge, a well-known local solicitor. George immediately resigned as town clerk, but Kelynge continued living extravagantly, completely indifferent to the plight of their creditors.

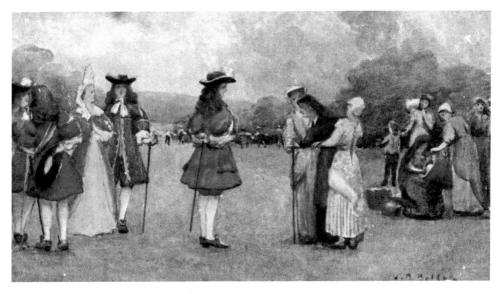

William III visits during the Warwick Pageant, 1906.

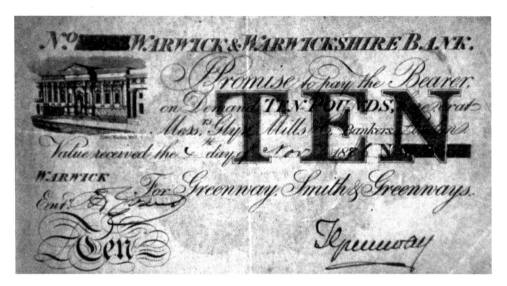

£10 banknote, Greenways Bank.

Evidence exposed their fraudulent dealings, including George misappropriating money from a charity where he was a trustee. They had given each other extensive personal overdrafts, and now employed top lawyers to help them evade their responsibilities. Both appeared at Warwick Assizes in July 1888. With his true arrogance, Kelynge kept the court waiting whilst he talked with his friends, no doubt confident of being acquitted. He was aghast to receive twelve months in prison, but George received five years.

When Kelynge left prison, he was seized by a waiting mob, frogmarched to the railway station, put on the first train to Birmingham and warned never to return. As the train started moving, it stopped to receive two late arrivals who shared Kelynge's compartment. Much to the crowd's amusement, they were a Birmingham police officer with a prisoner he had just collected. Kelynge was not amused.

In the 1980s, financier Keith Hunt, No. 46 High Street, disappeared with debts in excess of £6,000,000. He has never been found.

Murders

Abraham Thornton was tried here in 1817 for murdering Mary Ashford at Erdington, then in Warwickshire. His motive, allegedly, was her refusal to have sex with him, might possibly be proved. Likewise, the means of her death by drowning was possible, but the prosecution fell down on proving opportunity. Most of the evidence against him was circumstantial, aggravated by there being no standard English time when she died. Local areas set their own. Witnesses had seen him in different places at the same time, according to their local clocks, and, if true, he could not have committed the murder. The judge directed the jury to acquit him.

Considerable uproar followed and Mary's brother, William, had Thornton charged with 'Appeal of Murder', which was effectively, a private prosecution. Thornton counter challenged with 'Trial by Battel [sic]' by throwing down a gauntlet. 'Trial by Battel', still

Gauntlet, as used by Abraham Thornton.

remained on the statute book, albeit unused for several centuries. It was no contest as Thornton was larger and stronger than William. The 'Appeal of Murder and Trial by Battel' were withdrawn by both parties and soon afterwards these Acts were repealed.

Having the Royal Warwickshire Regiment (herein after referred to as RWR) barracks nearby, at Budbrooke, soldiers regularly visited the town, some of whom caused problems. One Saturday in November 1892, the body of James Russell was found in Priory Park, then home to what is now called Virginia House, which was transported and rebuilt in America. James had been beaten to death. Privates James Welch and Frederick Thomas King were arrested and charged with his murder, first appearing in court on the Monday. The local newspaper graphically described the court's steamed up windows as being like 'an exotic conservatory, less its purity and pleasantness of odour'.

Before appearing at the Assizes, details of the case were heard by the Grand Jury to decide if there was sufficient evidence to try them. The prosecution case fell apart when Russell's sister denied having seen them arguing earlier with her brother. Other evidence was circumstantial, leaving them no alternative but to dismiss the case, but the story does not end here.

Six years earlier, Police Constable William Hine of the Warwickshire Constabulary had been murdered in the village of Fenny Compton. Soon after these acquittals, a rumour spread that James Russell knew who the murderers were and had been murdered to prevent him telling anyone. Both murders remain undetected. William is buried in Evesham Road Cemetery, Stratford-upon-Avon. Just as embarrassing for the police, James had been murdered only a few hundred yards from constabulary headquarters.

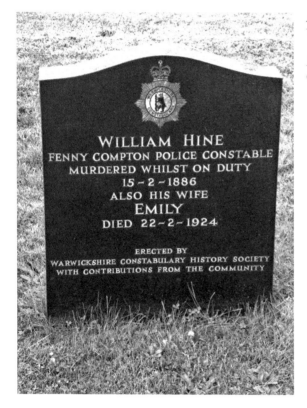

Above: Virginia House, Richmond, Virginia, USA.

Left: PC Hine's grave, Evesham Road Cemetery, Stratford-upon-Avon.

Riots

The Market Place, also called the Square, hosts the weekly markets and other events. In 1831, a general election was held with feelings running high. Electoral reform had not yet arrived. Warwick was a typical 'Pocket Borough', very much in the earl's pocket. He decided who would represent the borough in Parliament. There were no secret ballots. Very few men, and no women, had the right to vote. Those who did could be threatened or bribed as to how they voted. Despite bribery and threats, Sir Charles Greville, long standing MP for the town, lost his seat.

Market Square.

The Great Reform Bill was enacted in 1832, and the government fell in December. Parliament would sit again in January 1833, with the general election timed to take place over several days. It was a dirty fight. Greville set up drinking accounts for his supporters in many hostelries. New tenants moved onto the earl's estate, at reduced or no rents, and given voting rights, provided they opted for Greville. 'Cudgel men' were employed to intimidate his opponents.

Serious rioting broke out in the Market Place, causing damage and many injuries. It was stopped by a detachment of the Scots Greys who were billeted locally. More rioting occurred on polling day, spreading from the Market Place to the Butts. Polling booths were destroyed and voting suspended. Greville's supporters were delighted when he was elected, but complaints swiftly followed about the tactics used on his behalf.

In the ensuing enquiry, Parliament exonerated Greville, but agreed the election had only been won because of bribery and corruption involving the earl. A second enquiry revealed more corruption, with the borough boundaries being altered to accommodate Greville's supporters. To be fair Greville resigned immediately. In 1834 the earl was finally interviewed by Parliament. In the meantime, his agents had been busy, and most of the witnesses scheduled to appear against him declined to do so, undoubtedly having been threatened. The earl denied any knowledge of these devious tricks, blaming them on his agents and the matter eventually died away.

Treason

Warwick has had many less serious crimes than other parts of the country, but in November 1605, played a part in the Gunpowder Plot.

After hearing about the Plot's discovery, their leader Robert Catesby, led his dwindling followers from Dunchurch, near Rugby, to Warwick Castle. A local conspirator, John Grant, lived nearby, and had amassed horses for their use. Catesby rejected them, insisting on stealing better animals from the castle. A following hue and cry ultimately caused the deaths and arrests of the conspirators a few hours later.

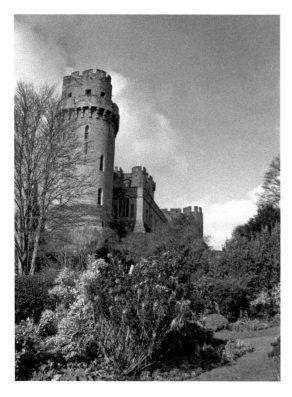

Warwick Castle.

Punishment
Courts
Warwick once had a magistrates' court for minor transgressions, Quarter Sessions held four times a year for serious matters, and the Assizes for the most serious offences. Assizes took their name from the French 'to sit' and were periodic court hearings, usually twice a year. Abolished in 1972, these last two are now called Crown Courts and sit most days. Magistrates' courts have remained largely unchanged except for numbers, venues and punishments. They can no longer use the pillory, the stocks or order floggings. On 'Public Punishment Days' prisoners were tied to the backs of carts and flogged between Eastgate and Westgate.

The old magistrates' courts sat at the Court House, in Jury Street, hence the statue of Justice over the main door. Northgate Street housed the old Assize, Quarter Sessions and Crown Courts. Situated behind this building, backing on to Shire Hall, is the ventilation shaft for the old cell accommodating over 100 prisoners, all chained to a central pillar at night and unprotected from the elements.

No longer used for legal matters, the old courts can be hired for functions. The annual Judges Procession still meets here for the opening of the legal year service in St Mary's and returning afterwards (Covid permitting). This is an old tradition well steeped in history. The two main courts retain an aura about them, traditionally being where the judge wore a black cap when pronouncing the death sentence. Film and television companies come here for filming purposes, such as the *Father Brown* series.

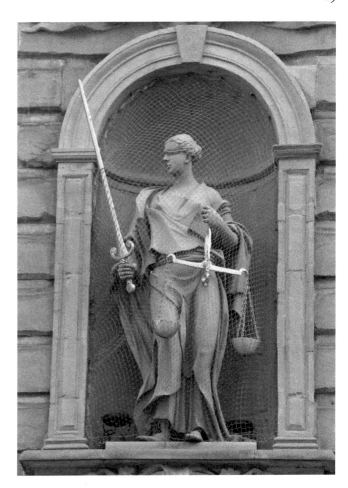

Right: Justice at Warwick
Court House.

Below: Old Courts in
Northgate Street.

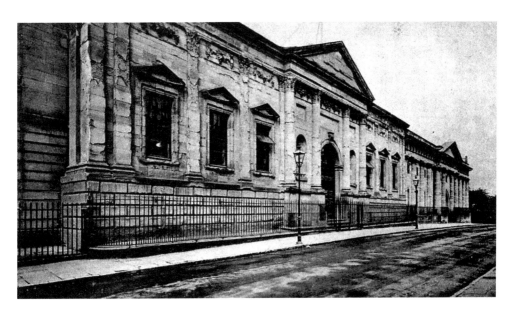

Cell ventilation shaft.

Judge's procession, *c.* 1930s.

Prisons

Being the county town, Warwick had prison facilities. The first was in Gerard Street before moving to Barrack Street, in the town centre, which was convenient for the courts. During the Great Fire, prisoners were released on humanitarian grounds, on the strict understanding they returned when it was out. It is not known how many did! Several stayed behind and helped rescue items from St Mary's.

Escapes were not unknown. George Bridgford escaped from the House of Correction in 1811. How he escaped was not detailed, but on recapture he could be sent to 'any of His Majesty's Gaols'. Four prisoners escaped in 1822 by forcing out an iron bar in their cell window and climbing down a rope made from their bed rugs.

Treadmills were erected in 1823:

> The Mill is to comprise three barrels, on which the young, the able and the middle-aged and the old offenders, judiciously classed according to their health and strength, will be daily exercised.

Prisoners had to climb 17,000 feet in ten hours. Not all tasks were pointless, and some mills inside the prison ground malt and split beans.

The town gaol sufficed until 1860 when transportation finished, resulting in a major nationwide prison building programme. Consequently, a new prison was built in 'a place called the Cape, near this Borough'. It was demolished in 1934 by Eli Pearson, who was fined £20 for drunken driving, and disqualified by Warwick Magistrates in 1941.

Warwick prison cell, the Cape.

During the First World War, it was closed for the reception of prisoners, but became a hostel, known as 'the Settlement', for conscientious objectors. The last execution here was of Harry Taylor Parker in December 1908 for a murder in Coventry. Henry Pierrepoint and John Ellis were the hangmen.

In 1868, London was hit by Fenian activities in support of their belief Irish Independence could only be achieved by violence. Following rescue attempts made at Clerkenwell, where twelve people died, London baulked at the thoughts of housing more Fenians. The panicking authorities had an idea when another two appeared before Bow Street magistrates on firearms charges. As these offences were committed in Birmingham, the prisoners were remanded to Warwick Prison, much to the concern of the Warwickshire authorities. Fortunately, a Rifle Brigade based at nearby Weedon was drafted in to help. Common sense, aided by the Queen's Bench Division, prevailed, and they were returned to London for subsequent trial. One was acquitted, but the main prisoner, Ricard [sic] O'Sullivan Burke received fourteen years imprisonment.

The old Governor's House remains, but the prison site is now covered by houses, and prisoners are taken elsewhere.

The crypt in St Mary's contains the remains of a ducking stool used to punish common scolds and gossips.

In Barrack Street, chains in the metal rings in the walls kept crowds back at public executions until the new prison opened in 1860. On the corner of Barrack Street there is an old cell door of the type used at the time of the fire.

Ducking stool.

Above: Execution site.

Right: Cell door.

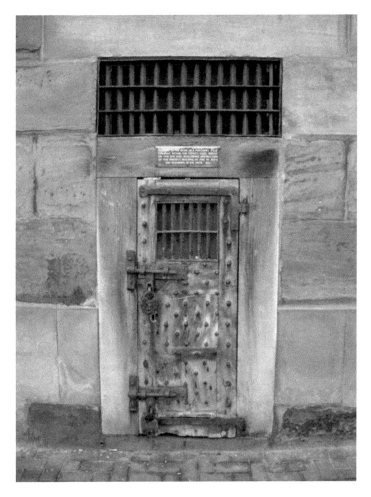

3. Military

Over the centuries, Warwick has seen much military activity, including being sacked on at least four occasions, and an ineffective siege of the castle by Royalist forces in 1642 before the actual start of the Civil War.

Militia
An auxiliary force, known as the militia, was first raised for use in Warwickshire during 1570 and remained until 1926. Participants trained for twenty-eight days each year, and the county's annual muster happened in Warwick. Substitutes could be employed and desertions were not unknown.

Miscellaneous
During the First World War, buildings like the Court House were acquired by various military organisations, such as the Army Pay Corps. Visiting troops were billeted in the town, which helped many families financially. The police arranged the billeting, excluding anywhere which was below basic standards, such as having no proper rubbish bins and only bucket-flush toilets. Local German prisoners of war could wander round the town but were not permitted to buy food, with harsh financial penalties, and imprisonment, for any who did and the vendors.

Army Pay Corps.

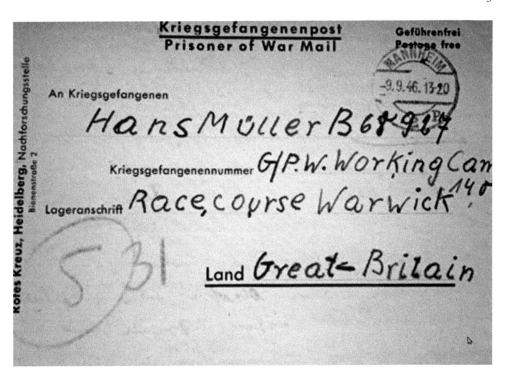

German prisoner of war card, Racecourse, 1946.

In the Second World War, a prisoner of war camp for Germans was situated on the Banbury Road opposite the old toll house. Another camp for Italians was situated on the racecourse, whose prisoners enjoyed much more freedom. Germans were later also placed here. They helped clear the roads during the heavy snowfalls in 1947.

There were never any real air raids here except one (see buildings – gasworks). Being close to Coventry, St Mary's was a landmark for the Luftwaffe flying there. Nevertheless, air-raid sirens were sited all over town. Practicing them at night in the early days of the war caused many complaints. People objected to having their sleep disturbed. Did they think air raids would only happen in daylight?

Following the big Coventry raid on 14 November 1940, the local media reported Warwick knew nothing about it. Really? The author has spoken to fire watchers at Kenilworth Castle, approximately 8 miles away, who saw major fires one night, which were identified as coming from London, so this suggestion of not knowing about Coventry cannot be true. Undoubtedly, censorship was at work, even more so when Warwick, and other hospitals, were used once Coventry ran out of facilities. The town soon provided reception centres for fleeing Coventry residents.

One night in 1940, firewatchers on St Mary's tower, currently undergoing major repairs, spotted a large light showing during the blackout from a house in the Butts. The following night they identified which one and the police visited. The householder was fined £10 and bound over to keep the peace. Her housekeeper, a neutralised German, went to prison for one month. Was she signalling to the Luftwaffe?

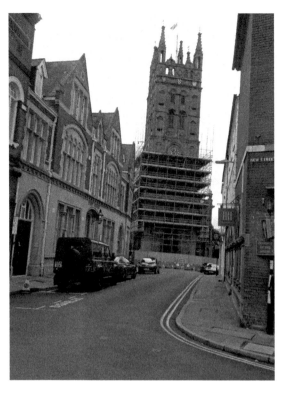

Left: St Mary's tower.

Below: Nelson public house.

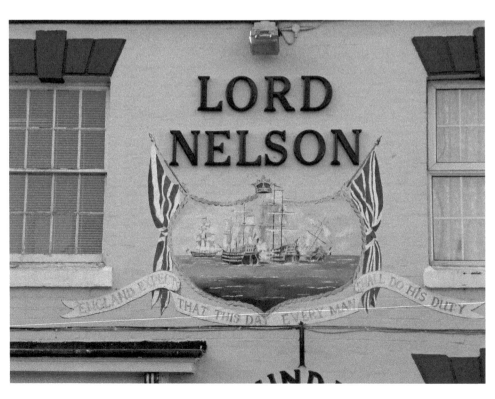

Royal Navy

Vice-Admiral Lord Horatio Nelson visited in 1802. When his coach arrived, it was stopped, and the horses replaced by young men. He was paraded around the town in such fashion. Unsurprisingly a hostelry named the Lord Nelson appeared in West Street in 1806, after his death the previous year.

During his funeral on 9 January 1806, St Mary's tolled a bell every minute, between noon until 1 p.m., and later at intervals during the afternoon. The current Nelson Inn, Emscote Road, once called the Beehive, had changed its name by 1866.

The Royal Warwickshire Regiment (RWR)

Originally the 6th Regiment of Foot, the now demolished RWR barracks were at Budbrooke. Their mascot was an antelope and is remembered by the Antelope Inn in the area known as the Saltisford, from being on the old salt way into Warwick. It was known as 'the first in and last out' by soldiers going on and returning from leave. The regimental tune is 'Warwickshire Lads and Lassies', created by the Shakespearian actor David Garrick, and is one of the carillons regularly played at St Mary's.

Antelope.

On their return from South Africa in 1901, troops attended a memorial service in St Mary's before enjoying 'a substantial lunch' at Shire Hall. During the meal, several of them caused alarm when, 'probably overcome by the moment and their lunch', they suddenly imitated a Maori war cry which they had learnt from New Zealand troops.

Sadly, the RWR lost its individuality with various mergers and now ceases to exist. St Mary's has hosted numerous major military services and customs over the years, including Remembrance Sundays, and the annual reunion services. It was the obvious location for the siting of the Regimental Chapel, completed in late 1939, albeit not officially used until after the end of the Second World War.

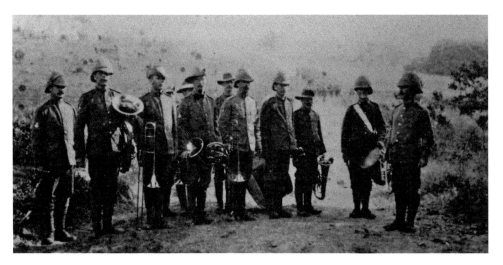

Royal Warwickshire Regiment, Natal, 1901.

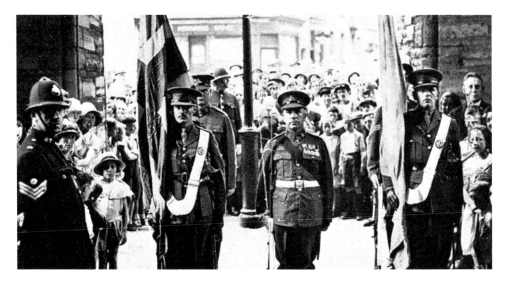

Royal Warwickshire Regiment entering St Mary's Church.

The most poignant reminder in the chapel is the stained-glass memorial remembering the little-known engagement at Wormhoudt, in northern France. During the retreat to Dunkirk in 1940, some RWR soldiers and others were detailed to delay the advancing Germans for as long as possible to enable more troops to escape. When their ammunition ran out, they surrendered, expecting to be treated as prisoners of war. Unfortunately, their opponents were members of the Leibstandarte-SS Adolf Hitler, who were not in a forgiving mood, believing, albeit erroneously, their leader had been killed during the fighting. Consequently, they set about murdering their captives, very few of whom escaped. Some were recaptured by the Wehrmacht and treated properly. For various reasons, nobody was ever prosecuted for war crimes over this incident.

Traditionally, St Mary's was the repository for the rolls of honour and the old regimental colours when they were renewed, and now hang over the entrance into the chapel. One banner belonged to Field Marshal Bernard Law Montgomery, 1st Viscount of Alamein, who began his military career in the RWR, and was wounded during the First World War.

Massacre site at Wormhoudt.

Left: Field Marshal Bernard Law Montgomery of Alamein's Banner, St Mary's Church.

Below: Enoch Powell's grave, Birmingham Road Cemetery.

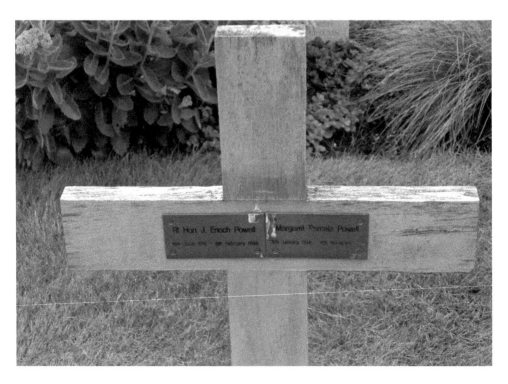

Inside the chapel, there is a plaque remembering the controversial politician, John Enoch Powell, once Member of Parliament for Wolverhampton, who served in the RWR during the Second World War. His political career ended when he was dismissed from the cabinet in 1968, having made a controversial speech against immigration. He supported repatriation of immigrants in what is often called his 'Rivers of Blood' speech. A regular attendee at RWR reunions, his funeral service was held here prior to interment in the Birmingham Road Cemetery.

Whenever there is a march past, the soldiers gather in Northgate Street. Local folklore says for many years, one of the houses had a stuffed bear in the window. As a mark of respect for Warwickshire's Bear Emblem, the marchers saluted it in passing. In between the wars, the bear was found to be filled with German newspapers and was never saluted again.

Plans have just been revealed to move the RWR museum to the Pageant House.

The Warwickshire Yeomanry
Not to be confused with the militia, the yeomanry was a cavalry regiment. Formed in 1794 during the French Revolution as the Gentlemen and Yeomanry of Warwickshire, they soon became the Warwickshire Regiment of Yeomanry. Many of these volunteers were small farmers, landowners and their tenants, becoming a military reserve. In the 1890s the 3rd Troop had stables in New Street where the Firmstone Company stands. Through the archway were the stables and an erroneous sign calling them the Royal Warwickshire Yeomanry. They never were titled Royal. Their assembly point for mobilisation in 1900, was on the racecourse. Originally, yeomanry regiments were not expected to serve overseas, but following serious defeats during the South African (Boer) War, volunteers served there and removed the bar to future serving abroad.

Firmstone's premises, New Street.

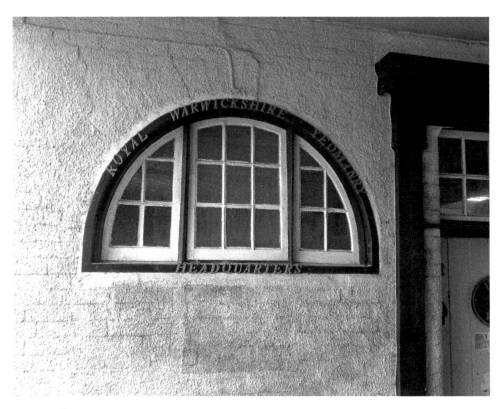

Firmstone's erroneous sign.

Woolpack.

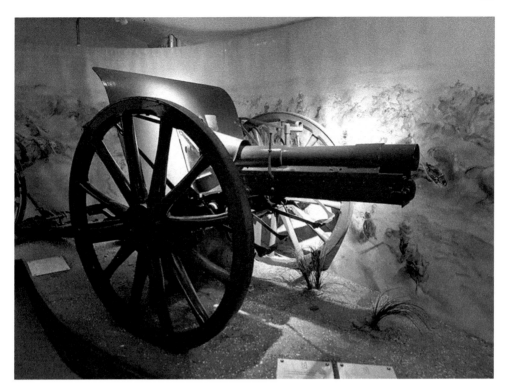

Gun captured from Turks at Huj, 1917.

With the outbreak of war in 1914, they were quickly called up for service. Their temporary headquarters were at the Woolpack, in the Cornmarket, but as the men arrived, they were dispersed all over the country for training and other duties. The regiment served in the Middle East during the First World War. In 1917, during the 2nd Battle of Gaza, they took part in the Affair of Huj, which was the last unsupported by artillery cavalry charge in British military history. One of the cannons captured there arrived at the Yeomanry Museum in the Court House eighty years later.

In 1939 they were still a horse regiment, being mechanised during the Second World War, seeing service in the desert and Italy. Today they form part of the Queen's Own Warwickshire and Worcestershire Yeomanry.

4. Entertainment

Ballooning

In 1821, celebrated balloonist Charles Green made a successful ascent at George IV's coronation. Following further successful flights, he arrived at the Satisford in 1824 for his nineteenth ascent from close to the gasworks. Spectators paid to watch the inflation of 700 yards of silk, in alternate colours of blue, crimson and gold, with 136,200 gallons of gas. He was accompanied by Miss Harriet [sic] who declined an offer of £50 (approx. £3,000 today), to let someone else take her place. Bad weather delayed the take off until 4 p.m. and the flight lasted for about sixty minutes, before landing near Lutterworth several miles away.

He flew again on 9 September and landed near Rugby, having first parachuted two kittens safely onto the Common. No tickets were issued this time, but collections taken instead. Genuine collectors wore silk balloon-shaped badges.

Boxing

Modern-day boxing is commemorated by a statue of Randolph Adolphus Turpin, 'the Leamington Licker', with local connections in the Market Place.

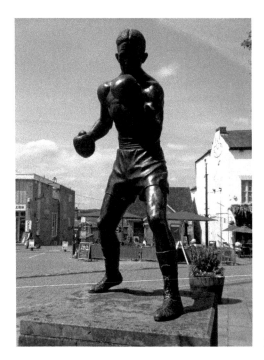

Randolph Turpin.

On 19 July 1825, a large prize fight between Tom Cannon and Jem Ward, for 1,000 guineas, occurred at Stank Hill, outside the local magistrates' jurisdiction. The contestants and supporters changed the venue several times, to prevent it being stopped. Ward won in the tenth round, and the results appeared that night in London, having been delivered by carrier pigeon. The temperature exceeded 90°F in the shade, and sellers of drinks and fruit made vast profits, with grossly inflated prices.

Carnivals

Warwick has enjoyed carnivals over the years, usually in early June, where the author and his family regularly took part. Latterly, he led the affair in his town crying role. Sadly, carnivals no longer happen. A Venetian fête was held on the River Avon in 1954, but never repeated.

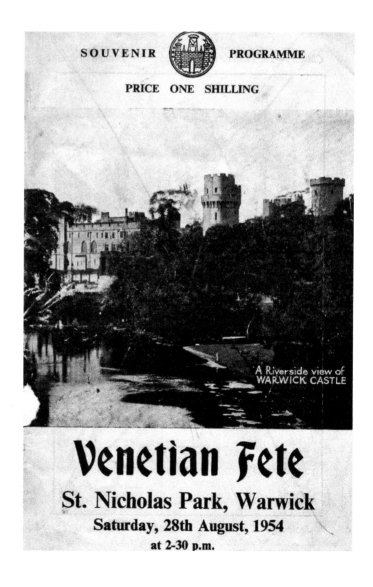

Venetian Fête programme, 1954.

Cinemas

Prior to the outbreak of the Second World War, the town had two cinemas. The Hippodrome, in Edward Street, was the oldest and had survived a chequered existence, including a serious fire. During the Battle of the Somme in 1916, it showed the film of the same name, which included footage of the RWR, and was retained for a further week by popular demand. By 1939 it was unsafe and closed.

The second was the County in St Nicholas' Church Street, which was so popular its queues regularly spilled onto the road. During the Second World War, it relied on teenagers and older men to operate the projectors after the regular operators were called up. This cinema has long since gone.

In 1939, the Warwick Cinema opened in Coten End, later replaced by the Donald Healey. Motor Company. The author remembers going there to the Saturday morning children's film club. The residential complex named Healey Court now occupies the site.

During the late 1930s, the council missed the chance to purchase Eastgate House, in Jury Street, to use as a cinema. The building became the headquarters of the local Air Raid Precautions Unit.

Healey Court.

Eastgate House.

When the author was growing up in the post-war years, films were given a U certificate enabling all to watch unaccompanied by an adult. The next category was A, which children could watch if accompanied by an adult. It was a time when main titles were supported by lesser ones, showing two films to watch. Cinemas sometimes had a major film with a U certificate, supported by another with an A certificate. If no family members were available, you waited outside and asked older couples to take you in, obviously paying your own way. Many did so but would not dream of doing so today.

Exhibitions

Before the advent of television, radio or films, exhibitions attracted numerous visitors, and the more unusual the exhibits, the better. For instance, the stones which had choked a horse weighed 3 lbs 4oz and could be viewed in the Black Horse at 6*d* per person. In 1810, a *Squalus Maximus of Lineaeus* or a basking shark was displayed on the racecourse. It had been caught in 1809 and measured 31 feet long, 19 feet in girth and 9 feet 2 inches high. Was it a fake or a fraud in 1824 when a thoroughbred mare with seven legs was displayed?

Market Place

The Market Place hosts numerous festivals. In July 1832, it housed The Warwick Festival for 2,500 people who consumed 4,000 lbs of beef, 1,500 loaves and 1,400 gallons of ale, served up on thirty-six tables.

Folk Festival.

For many years, Warwick has hosted an annual Folk Festival in July, involving the town centre and other venues. Folk singers, Morris dancers and other entertainers make it a very colourful event. On the Sunday, there is a civic service in St Mary's where some of them entertain the congregation. On his last civic service before moving to Portsmouth, Canon David Brindley surprised many by confessing he was a secret Morris dancer. Stripping off his clerical robes and revealing his Morris clothing underneath, he joined in a dance.

Greyhound Racing

The former Greyhound public house in Emscote Road was a reminder of this pastime, but now, like the actual track, it has gone. A new housing estate, approached by Sir Anthony Eden Way, has replaced it. He was the local Member of Parliament for several years, winning the seat on one occasion from his socialist opponent, the Countess of Warwick.

Horse Racing

Opening in 1707, Warwick's racecourse still operates. The Cheltenham Gold Cup was once raced here but not any longer. In Castle Street, an inn, the Gold Cup, now called Jambarvan, commemorated this race. Prior to the races starting, cockfights were held, usually at the Navigation Inn, now called the Antelope. These contests were between the 'Gentlemen of Warwickshire and the Gentlemen of Staffordshire'.

Approach to the Greyhound site.

The infamous Dr William Palmer, alias the 'Rugeley Poisoner', visited here, where he won large sums of money, developing a taste for gambling, but became a very accomplished loser.

Complaints arose in 1809 about the 'most indecent and abominable songs' being sung on the site. For many years, Birmingham City police officers policed the event. Many of the troublemakers and criminals were already known to the visiting officers. Not everything went to plan, and in 1826 whilst helping at the theatre, two officers had their pockets picked.

Although summary justice was meted out, it did not always work. A young pickpocket was caught, whipped and released. Within the hour, he had been caught again with more stolen handkerchiefs on him. His fate was not recorded.

Lions and Dogs

Whilst the Warwick magistrates were complimented for driving the Cannon versus Ward fight out of town, they were criticised for not stopping the lion and dog fights in the same month. George Wombwell promoted dog fights between his two lions, Wallace and Nero, in the Saltisford. Wallace successfully beat off his attackers, but Nero was not so lucky. He was pinned down and needed to have the dogs pulled off him. George Wombwell denied he had lost and refused to pay up. Only when Nero was pinned down for a third time did he pay out the winnings. Wallace's body was later stuffed, and can be found in Saffron Walden Museum, Essex.

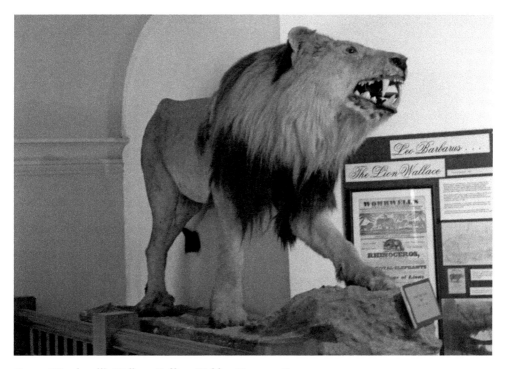

George Wombwell's Wallace, Saffron Walden Museum, Essex.

Although Nero was deemed too tame for fighting, he attacked a man a few days later at Oxford Races when he leant against his cage. The man was the keeper of one of the dogs who had attacked him at Warwick.

Mop Fairs

Today's annual events are the modern version of the old hiring fairs, where people attended seeking employment or to change it. They are named after the practice of hopeful skilled employees carrying tassels, known as mops, in their buttonholes indicating their occupation. Those who had no trade carried a mop head. At the end of the following week, they could change employers or employees, at what was called the Runaway Mop.

The official opening of the Mop happens on a Saturday at noon, when the mayor reads from the charter authorising the event. The official party is escorted around various activities, followed by numerous children taking the opportunity of free rides. The mayor carves the first slice of the hog roast, which the town crier auctions for charity. A member of the Showmen's Guild of Great Britain – Midland Section buys it and then offers it for resale. Up until the 1970s, an ox was traditionally spit roasted, but now it is a hog. Few people have the skills to roast an ox, which is a lengthy job. Episode 8 of the 1930 Warwick Pageant, held in the Castle Park, is called Warwick Mop 1759. It includes the tune of 'Warwickshire Lads and Lassies', which was not composed until 1769.

Pageants

The first recorded one happened in 1906, and many parts of it were filmed. Postcards, both photographic and illustrated, can still be found today. Other pageants included one for Queen Elizabeth II's coronation, which the author can remember seeing.

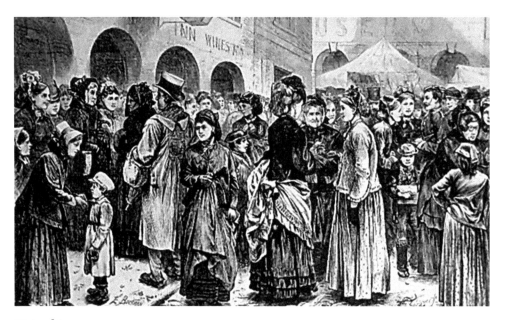

Hiring fair.

Parks and Gardens

The College Gardens adjoining St Mary's churchyard are a haven of peace and quiet. Being privately property, the owners sometimes exercise their right not to open them.

Hill Close Gardens are where the town's Victorian residents, who did not have any gardens, could acquire an area in which to relax, grow plants or entertain.

The Mill Garden, created by Arthur Measures, is run by his daughter Julia and her husband David. Situated at the bottom of Mill Street, it provides close-up views of Caesar's Tower and the ruins of the old bridge, which Father Sugar crossed on his final journey.

Priory Park is a natural area, once being the grounds of the former twelfth-century priory of St Sepulchre, and later the old house before it was shipped to the USA. It was home to Amikaro International Scouts Gatherings in 1958 and 1979.

College Gardens.

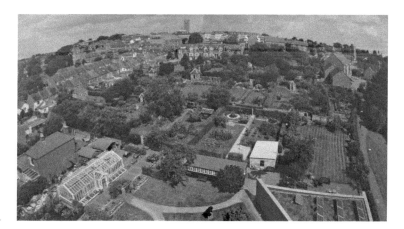

Hill Close Gardens.

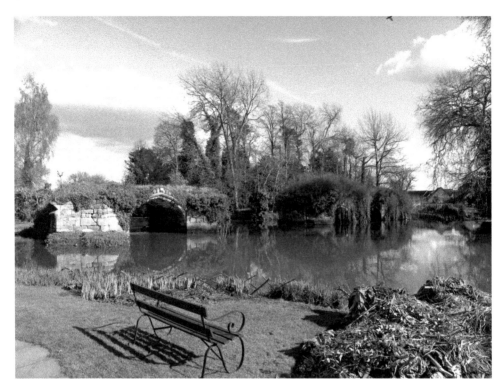

The Mill Garden.

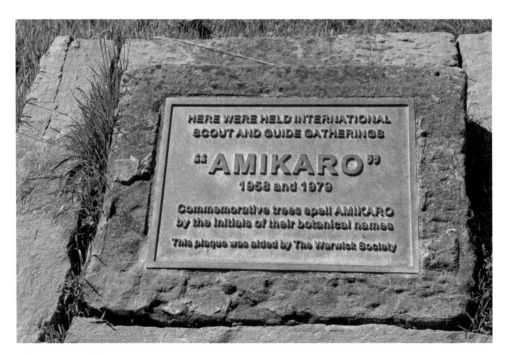

Priory Park, Amikaro.

St Nicholas Park is a honeypot for visitors in the summer, with its paddling pool, boating and various other attractions. Prior to 1974, it housed the local council's plant hothouse, which was a godsend to the beat bobbies on cold nights. The adjoining St Nicholas' churchyard has paths that were just wide enough for the police mini panda cars to drive through.

Pedestrianism

Walking activities in the nineteenth century were ultimately replaced by modern race walking. It originated from the aristocracy's running footmen who accompanied their coaches and raced one another.

In July 1818, the racecourse was the venue for Oxford and Banbury Pedestrian Jones [sic], who would walk 120 miles in two successive days. The first day lasted twelve hours and the second an hour longer. It was estimated 2,000 spectators paraded him through the streets on completion.

His next challenge came in September, when he walked 210 miles in three days, during incessant rain. He ended on stage at the theatre, where he was showered with money. On the following Monday he was paraded through the town with a band playing 'See the Conquering Hero Comes'. His friends collected money for him from the spectators.

His rival Richard Williams walked 60 miles from Leamington to a house in Myton Road. Unfortunately, the route had been measured incorrectly, which resulted in the full length being 2 miles and 80 yards too short.

Shows

The Second Royal Show was held in the Great Park at Warwick Castle in 1892. Other shows and fêtes, etc., used Priory and St Nicholas' parks.

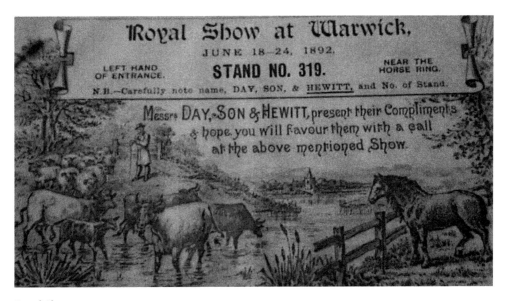

Royal Show programme.

Theatres

This type of entertainment was particularly popular when there were race meetings and the Assizes/Quarter Sessions sitting. The venue was sited in Theatre Street.

TV *Dangerfield*

Set in and around Warwick, the main character, Paul Dangerfield, is a police surgeon based at the Old Dispensary in Castle Street. This was where the late Dr John Busby had his practice. One episode required an explosion in the surgery, so a replica was built in the studio and blown up. In another, a local house was used for a student hostel with cannabis plants growing there, which the police would not allow. A compromise meant someone had the job of cutting tomato plant leaves to resemble cannabis. It took them all morning and then they were not used. St Mary's was used for a wedding scene with David Brindley acting as himself.

Old Dispensary.

TV Lord Leycester Hospital

With its wealth of old buildings, the Lord Leycester Hospital, in High Street, has found a useful source of income by being used for various film and television productions. Amongst these have been a programme about the *Plague of 1665–6* and fleetingly a piece of *Pride and Prejudice*. In more recent times, *Doctor Who*'s TARDIS has been parked here, and the hospital was used for a recent version of *A Christmas Carol* and the *Shakespeare and Hathaway* series.

Lord Leycester Hospital.

5. Communications

Air

RAF Flying Training Command 23 Group airfield was situated on land adjoining the Stratford Road between 1941 and 1946. With a grass runway, it was a relief landing ground. The ruins of its last hangar have been removed. Much discussion took place, post-1945, concerning the building of a commercial airport in the district. Warwick was suggested, but nothing came of the idea.

Canals

Flowing through Warwick towards London and Birmingham, the Grand Union Canal, created in 1927, is the amalgamation of various smaller waterways, including the Saltisford Arm. Constructed in 1799, the Birmingham–Warwick Canal ended opposite the old gas works and supplied fuel for them. With the growing demand for houses in the locality, the Arm became disused, overgrown and in some parts filled in. The Saltisford Canal Trust was formed, who rescued and restored as much of the Arm as possible. Unlike its original construction, they had proper plans in preference to relying on a telescope and wooden stakes. The Arm now ends at the railway bridge and is a popular mooring spot.

Speeds and times were regulated for ordinary narrow vessels, but fly boats, as they were called, operated twenty-four hours a day, using teams of horses non-stop. They could occasionally achieve speeds of 10 mph but were hindered when passing through locks and

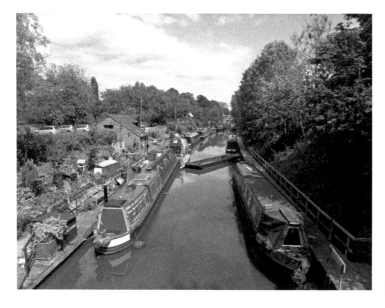

Saltisford Arm.

tunnels that had no towpaths. On the Birmingham side is the Hatton Flight, consisting of twenty-one locks in less than 2 miles. Negotiating a tunnel meant men lay on top of the vessel and walked it through using the roof and sides. This is known as legging and ultimately caused health problems for the leggers.

Fly boats had right of way, enforced by a blade in their prows for slicing through tow ropes of crafts who failed to move aside. Pickford's boats visited Warwick every Wednesday and Thursday. Canals were unable to compete with the railways and lost trade. Looking at the King's Head in the Saltisford, today it is difficult to realise this once had stabling for fifty horses, some of which would have been used on the canals.

Mail

Henry VIII began England's postal service, which enabled his agents to see who was corresponding with who. In 1654 Olive Cromwell set up local services, but a uniform system did not appear until 1840, thanks to Rowland Hill, who made important changes. Senders of letters now paid for their delivery, unlike previously when the recipient was responsible. The receipt was a stamp fixed to the envelope, and houses needed numbers to make life easier for the postmen.

Pillar boxes, as they were called, received mail for onward transmission. Post Office official and author Anthony Trollope invented them. Originating in Jersey during 1852, they appeared the next year on the mainland, painted green but later changed to red. Their name came from the early French metal pillars which were used for mail collection.

Two early examples, erected c. 1856/7, remain at Eastgate, and Westgate, shaped liked Doric columns, with their original vertical slots for mail. These were impractical in keeping rainwater out and were replaced by horizontal ones.

Eastgate pillar box.

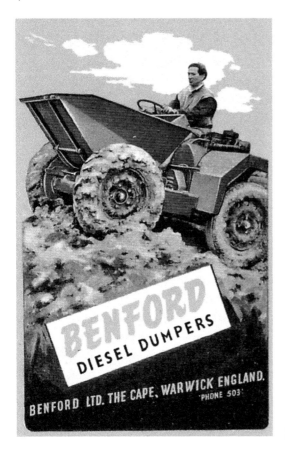

Benford playing card.

Motor Vehicles

Experts disagree on the exact date, but the first appearance on our roads of a motor car was believed to have been around 1894/95, and transport changed again. Donald Healey, a former Warwick schoolboy, started making motor cars at the rear of Benfords, in Cape Road, and later moved to what is now Healey Court. The advertising back of this playing card gives some indication of their work. Before owners'/keepers' details were computerised, all Warwickshire records were kept in Shire Hall, with Warwick police officers checking them out of hours.

Railways

Warwick's station opened in 1852 and was an original broad-gauge line used between Oxford and Birmingham. Just outside the station, en route to Birmingham, is the Hatton Bank, with a gradient of 1/105 in 2.5 miles. Whilst not the slowest of gradients for passenger traffic, freight trains needed extra engines for ascending, kept in sidings by the Cape Road railway bridge. An extra line was built specifically for freight trains to use and not slow down other traffic. It was removed in 1969. Steam trains still pass through evoking memories of seeing red fires burning in the cabs at night. The *Royal Scot* is one of them, shown here in September 2021, reliving its earlier steam days on this route.

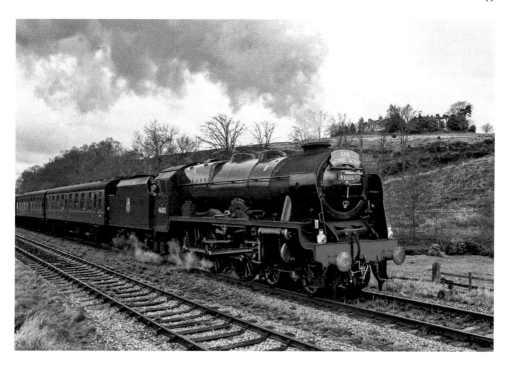

Above: The *Royal Scot.*
(Charlie Jackson)

Right: George Throttler Smith.

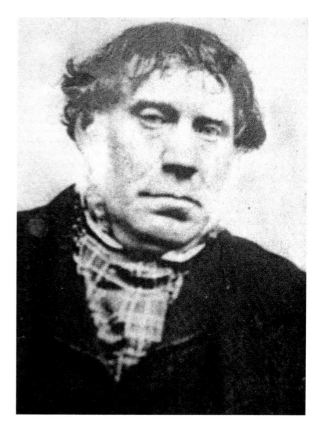

In October 1860, public hangman George 'Throttler' Smith officiated at the first execution in front of the new prison. The execution was delayed for three days, and a larger than usual crowd assembled for the event, only to discover about a third of them could see it. Then, 'Throttler' hanged the prisoner before he had finished praying. The very unhappy and angry crowd, mainly from Birmingham, arrived at the station for their trains, where they found 'Throttler' and set about him. Seizing 'Throttler', they pushed him onto the railway line, allegedly to be run over by the next train. He was saved by the stationmaster.

'Throttler' hanged Dr William Palmer (see horse racing above) at Stafford in 1856.

Stagecoaches

Unless they had money, most people travelled by foot. Horses, and their upkeep, were the privilege of the rich. When goods needed moving, they were transported by carriers using wagons, which were heavy, slow, and used the existing poor roads. Alternatively, strings of horses or mules were used. As roads improved, purpose-built vehicles appeared. Numerous carriers operated countrywide from smaller inns or private houses.

The first passenger coaches arrived in London, during 1605 and gradually their speed and capacity improved. In 1794, the country's slow and inefficient postal service changed dramatically when John Palmer introduced his concept of fast coaches, carrying mail and passengers. This rapidly growing traffic spread to other coaches, with speed becoming all important. Warwick soon became an important transport centre, as more services and routes sprang up. For example, in April 1829, mail arrived from London at 6.58 a.m., and from Birmingham at 7.56 p.m., but whose time was used? (See Crime and Punishment: Abraham Thornton.) In 1820, someone complained about the variance in times shown on Warwick's clocks, often by fifteen to twenty-five minutes. Timings did not standardise until 1840. Coaches could be delayed by the forces of nature such as flooding or dense fog. Coach horses worked in stages of 10–15 miles before being changed.

Mail coaches were the cream of stagecoach travel, with drivers keeping to the legal speed and capacity limits. They employed mail guards, often ex-soldiers at 10s 6d per week (approx. £23 a year), plus a sick benefit scheme, and 2 guineas (approx. £92) funeral expenses. Guards were armed but restricted to only firing in self-defence. Wearing a red coat and carrying a long coaching horn to warn of their approach made them easily identifiable.

During the nineteenth century, stagecoaches acquired names such as the *Crown Prince* and the *Telegraph,* which operated from Warwick's major hotels. The Warwick Arms had stabling for sixty-six horses. Its wall at the rear, off Back Lane, was chamfered to allow coaches to turn more easily into the yard. Coaches operated 24/7 to use modern-day parlance, covering the major routes all over the country. Numerous regulations appeared, such as forbidding travellers sitting on luggage, drivers going too fast and toll house keepers refusing to count passengers or measure height of luggage. Paid informants made plenty of money.

Mishaps occurred. One evening in October 1819, the *Crown Prince* collided with piles of rubble in the Saltisford and overturned. Nobody was killed, but two ladies were unable to continue their journey. In 1822, a young man was killed in Jury Street, after trying to

Rear of Warwick Arms.

leap onto a coach's rear when passing. Two days later, one of the jurymen from the above inquest was seriously injured when he tried to do the same.

Later that year, a seventy-years-old man was killed by a coach in the Market Place. Being deaf, he had not heard it coming, nor the coachman's cries. The inquest verdict was accidental death with a deodand of 1s (approx. £2.80) placed on the coach. A deodand was something given to God following the death of someone by something. The practice was abolished in 1846.

With all the horses and mules coming into Warwick, leather works were a major business, but there was one problem, which not even the Victorians could solve. How to dispose of all the manure? For instance, by 1902 there were 3,500,000 working horses in Britain, who required 15,000,000 acres of land for their food. At the same time, they produced 10,000,000 tons of manure.

Coaches put many canal companies out of business just as the railways did to them.

Trams

Arriving in England from America around 1860, they reached Warwick in 1881, despite having been planned years earlier. Initially horse drawn, they travelled between Leamington and Warwick, becoming electrified in 1905. The Warwick Arms was the terminus, and as many as eight trams could be on the tracks at the same time, with passing places. They were open-topped double deckers, needing extra horses to pull them up Smith Street and High Street. Once the tramway was built, it was discovered

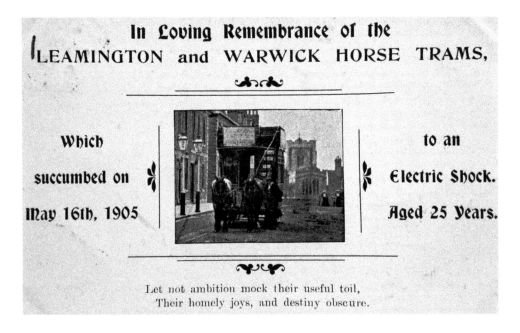

In Loving Remembrance of the

LEAMINGTON and WARWICK HORSE TRAMS,

Which

succumbed on

May 16th, 1905

to an

Electric Shock.

Aged 25 Years.

Let not ambition mock their useful toil,
Their homely joys, and destiny obscure.

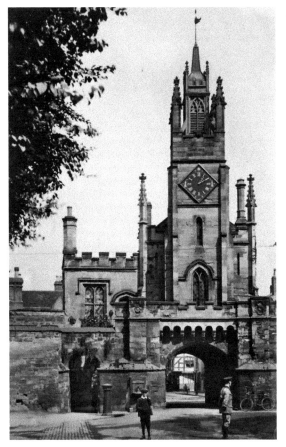

Above: Tram electrification, 1905.

Left: Eastgate Arch.

the Eastgate arch was too low to get under. Instead of rerouting the track, hurried new regulations prohibited passengers remaining on the upper deck when going underneath the arch. The author knows how young men stayed on the top to impress the ladies. After becoming electrified, the problem was solved as trams were rerouted round the arch between it and the Castle Arms.

Emscote Power Station, now adjoining Tesco, on the River Avon, was initially built to supply electricity for the trams. Coal arrived by canal, and water came from the Avon. Accidents were not unknown, as in January 1916, when a runaway tram from the Warwick Arms collided with the Castle Arms.

Modern motor omnibuses provided a serious challenge, insisting on driving up Smith Street in opposition to the trams coming down it. Unable to compete, the last tram ran in August 1930, and removing their tracks began within days. The cable holders, like these in Jury Street, remained for a while, being converted into lamp posts, although they have now gone. The overhead tram wires in High Street were used on 11 November 1918 to hang an effigy of the Kaiser.

An old Warwick tramcar can be found at the National Tramways Museum at Crich in Derbyshire.

Until the 1970s, the road known as New Bridge crossing the Holloway was a growing problem for higher vehicles, including buses, becoming stuck underneath it. Consequently, it was filled in having once been the main entrance into town from Birmingham.

Model of tram crash, Eastgate, 1916.

54

Old cable holders.

Banbury Road Toll House.

Toll Houses

Unpopular hinderances to traffic, these have been a feature of travel for many years, requiring travellers to pay fees for using certain roads. Exceptions included going to and from church on the Sabbath and for funerals. Royal Mail coaches were exempt, and it was an offence to hinder their progress. The guard sounded his horn well in advance, and the gates had to be opened in time for their arrival. Although now a private house, the old toll house on the Banbury Road at its junction with Gallows Hill once sold sweets and ice cream.

6. Curious Clergymen

Sabine Baring-Gould

A Warwick School pupil in 1845 before it moved to Myton Road, Sabine later went to Cambridge before taking holy orders. As a curate, he shocked people by marrying a teenage mill girl and moving to a Devonshire parish. Before marrying Grace, he had her educated and taught the manners of society. It was a successful marriage, lasting forty-eight years and producing fifteen children. In 1872, he inherited the lordship of Lew Trenchard, on the edge of Dartmoor, taking over the parish in 1881. He cared greatly for his parishioners, often arriving to see them in a coach and horses.

Sabine remained an avid novelist, collector of folklore, song and hymn writer, responsible for publishing the song 'Widdicombe Fair', but he recorded nothing from Warwickshire. He is probably best known for the hymn 'Onward Christian Soldiers', which he wrote in 1865, and his music titled 'Warwick School' is one of three tunes and is used there in his memory.

William Brookes

Always known as 'Mad Brookes', William lived at the Bear and Baculus (Bacchus) Inn adjoining the Lord Leycester Hospital. One afternoon in 1812, he shot Hannah Miller (14) dead, for no apparent reason. He was acquitted of her murder at the Assizes due to his obvious mental state, hence his nickname, but was detained indefinitely, however, as a precautionary measure.

Thomas Cartwright

An outspoken Puritan minister, born in 1535, he fled to Ireland to escape Queen Mary. On his return, he campaigned for the reform of the Church of England from within. Whilst his sermons and lectures were popular with the masses, they were not with the authorities, and he fled the country again. Unwisely returning in 1585, he was immediately arrested and thrown into the Fleet prison. Here, he came to the attention of Robert Dudley, Earl of Leicester, who appointed him the second Master of the Lord Leycester Hospital [sic] where he continued being provocative and hard working.

He rose daily around 4 a.m. and worked on translating the New Testament into English. On Sunday mornings he preached at St Mary's, and in the evening at St Nicholas', giving his annual income to the poor. Unsure of how to deal with Thomas, the authorities left him alone. He died in 1603 after a short illness and was buried in St Mary's churchyard. Unfortunately, his grave was lost during the Great Fire.

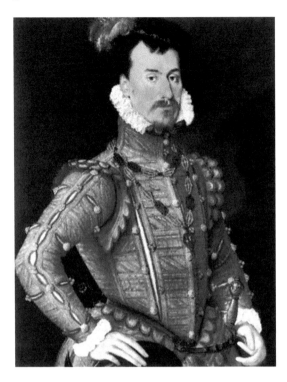

Robert Dudley.

William Edes

William was a difficult vicar at St Mary's. In late 1687 he read out a thanksgiving proclamation for the birth of a son to James II, who would become known as the Old Pretender. The church bells were rung, but the news was received in absolute silence by the congregation. They were concerned by him clearly supporting the king's move towards restoring Roman Catholicism in England. He made matters worse by laying a coin stone over the door of the new Catholic chapel in the Saltisford, insisting the letter 'E' for Edes was put on it. James II seized numerous town charters, including Warwick's. This task fell to a Lieutenant Edes, William's brother, who happily helped him. Despite his actions, Edes remained vicar until 1706.

William Field

Born in 1768, his mother was descended from Oliver Cromwell. In 1789 William became minister at the Unitarian High Street Chapel, although he was not ordained until 1790. Dr Joseph Priestley, of science and religious fame, preached the ordination sermon. Priestley later caused serious rioting in Birmingham and fled to America where he later died. The first Sunday schools were established in Warwick in 1787, but the other Anglican churches objected to William starting up his own. They accused him of using the school to undermine the Established Church, and demanded it was closed. William refused and a series of written pamphlet wars followed, as did more controversy. A tea party was held in July 1825 in the Race Stand to commemorate his thirty-fifth year of service.

Right: Unitarian Chapel.

Below: Sunday school mug.

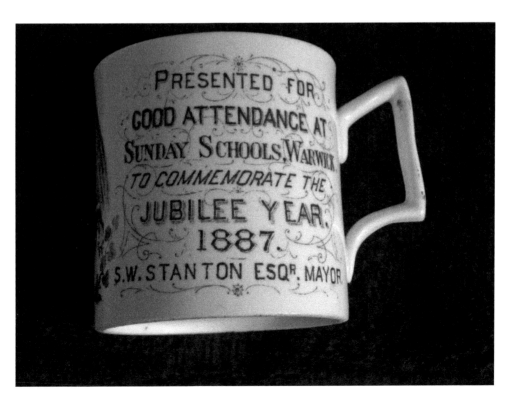

On William's arrival, the chapel had an urn on its roof, which he replaced with a cross, leading to accusations of him having papist tendencies. He supported religious freedom and parliamentary reform whilst the French Revolution raged. Undoubtedly his views and friendship with the radical Samuel Parr and Arthur Savage Wade (see below) would have caused concern in some places. He also helped start the *Warwick Advertiser* in 1806.

He is best remembered for his book *The Town and Castle of Warwick*, which appeared in 1815, one of whose first purchasers was Sir Walter Scott. His section on Warwick remains a main source of reference for historians. In particular, he mentions lace, hat, cotton and cloth manufacturing as being important trades.

From 1830 he was Unitarian minister at Kenilworth until he resigned in 1850, dying the following year. He resigned from Warwick in 1843, but still preached regularly at St Nicholas' Church.

Joseph McCulloch

'Holy Joe', as the author remembers him being called, can best be described as an unconventional cleric who arrived at St Mary's in 1949. The Bishop of Coventry appointed him with the instruction to 'stir up stuffy St Mary's'. Being unimpressed by the church furniture, the suggestion was made 'to put the whole lot in the street and start again'. Having heard the previous five rectors had 'broken their hearts here', he was determined not to be defeated and remained in post until 1959. Being outspoken soon made him a controversial character. For instance, he suggested most of the Queen's coronation speech was nothing more than 'well-intended waffle'. He accused the Church of England of being 'imprisoned and confused about its past'.

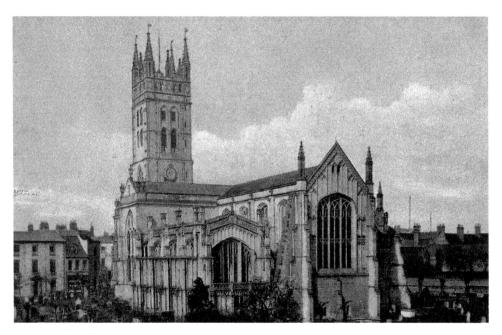

St Mary's Church.

Despite his diverse opinions, he cared for St Mary's and remembering the bishop's comments, determined to clean, restore, and declutter the building. He moved the altar to where the transepts crossed in the church, which was a revolutionary concept. He was summoned before a consistory court, accused of not having had these alterations properly carried out. It was later agreed he had. Another plan involved his parishioners abandoning what he called 'triumphalism and undue pride in past glories'. It is a moot point how well he succeeded.

On his departure to St Mary-le-Bow, where he was even more outspoken, the *Warwick Advertiser* observed he should be remembered for his good works and not his controversial ministry. With a touch of irony, he replied 'as having become part of Warwick's history … I willy-nilly had added to its triumphalism'.

John Newton

Whilst not spending long here, Warwick played a part in persuading John to enter the Church. The son of a merchant navy captain, he went to sea at the age of six following his mother's unexpected death. After various voyages, including time in the Royal Navy, he became a slave trader. Learning how his father was looking for him, John decided to go home on another ship as a passenger. Having nothing to do, he drank heavily and blasphemed so much – he was hated by all – that the crew wanted to throw him overboard, fearing he would lead them into disaster. During a particularly bad storm, he helped keep the ship afloat, and was heard to say 'may the Lord have mercy on us'. They finally arrived safely at Liverpool.

Brook Street Chapel.

John went on more slaving expeditions, but he was now a changed man who did not drink, swear, blaspheme or yield to other temptations on board such ships. Ill health made him leave the sea and think about religions, especially Nonconformist ones. In 1758 his application to take holy orders, in the Church of England, was rejected and he turned towards a Dissenting church. Still undecided about his future, he came to Warwick in 1760 as a temporary pastor at the Independent Chapel in Brook Street, then called Cow Lane. He stayed here for three months.

One Sunday, during the latter part of the seventeenth century, the local constables broke up a Dissenting meeting and arrested the pastors. They were taken to the Court House to await the duty magistrates, who did not appear. Constable Vennor, a kindly man, suggested each constable took a pastor home and fed them. He found his guest so interesting that he became a Nonconformist. It was his grandson who invited John to Warwick to try his hand at a ministerial career. John was finally ordained into the Anglican church in 1764 as curate of Olney. He was married to Mary for forty years and she was the only love of his life.

Although described as a poor preacher, he regularly enjoyed large congregations and became a prolific hymn writer, probably best remembered for 'Amazing Grace'. Moving to London in 1780, he met William Wilberforce. The two men became staunch allies in outlawing the slave trade, of which John had once played such a part. He lived just long enough to see the Act abolishing the slave trade enacted.

John had fond memories of his time in Warwick and always recalled his time here with pleasure. Constable Vennor's grandson remained his life-long friend.

Samuel Parr

Although the curate at nearby Hatton, Samuel regularly visited Warwick, especially the gaol, causing him to promote radical changes in the law. He believed the death penalty should remain, but only for murder and treason. In 1786 he became the perpetual curate of Hatton, where he was a model parson to his flock, only relinquishing the post on his death in 1825. He bequeathed £10 in his will for the prisoners in Warwick Gaol.

Unlike many of his contemporaries, he favoured religious toleration and numbered William Field as a friend. He was also friends with John and William Parkes, great supporters of Field's ministry and Warwick factory owners. In 1824 he married John's son, Joseph, to Dr Joseph Priestley's granddaughter Elizabeth, who became grandparents to Hilaire Belloc. He knew Arthur Wade (see below). Undoubtedly his radical views, plus support for Queen Caroline, George IV's estranged wife, ensured he did not progress any further in the Church hierarchy. Walter Savage Landor (see below) regarded him as a father figure, and Hatton as his second home.

A lover of folklore and customs, Samuel became a legend in his own right. Easter Mondays and Tuesdays were known as 'lifting days'. On Monday, the men picked up all the women and kissed them. The girls returned the compliment on Tuesday and included Samuel. His mode of dress added to his eccentric reputation, and he was seen regularly between Hatton and Warwick wearing an old blue coat, coarse stockings, a cauliflower wig, small hat and one spur.

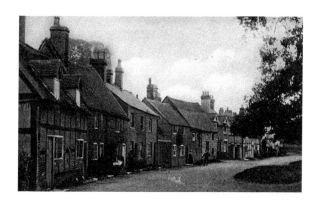

Bridge End.

Father John Sugar

Being a Jesuit, when religious intolerance was rife, was a dangerous occupation with a short life expectancy. In 1603, he was arrested at nearby Rowington, and appeared at Warwick Assizes in 1604, charged with treason. Jesuits were both feared and hated in Protestant England. His guilt and death sentence were foregone conclusions.

On 16 July 1604, he was tied to a hurdle and dragged behind a horse to Gallows Hill, via Bridge End, where he suffered the dire penalty of being hanged, drawn and quartered. The four parts of his body were displayed on the roads leading into Warwick. Throughout his ordeal, Father John was accompanied by his faithful servant Robert Grissold, who was given numerous opportunities to revert to Protestantism, but he refused and was hanged. Both were beatified in 1987 for their martyrdom.

Reverend Sturgis

Very little is known about this man except he applied for the position of Warwick Gaol chaplain in 1826. He arrived from Birmingham on a borrowed horse, which was not returned. A few days later, Sturgis wrote to the owner saying the animal had gone lame, and he had sold it for £8, which he had kept. On being arrested, Sturgis was lodged in the same prison where he had applied to work. The magistrates decided it was a civil matter and not a criminal one. Sturgis was described as being 'a disreputable character, unable to prove an honest day's work in the past twenty years'.

Arthur Savage Wade

Another controversial cleric, Arthur was born in 1787 at Warwick. Becoming vicar of St Nicholas' Church in 1811, he technically remained here until 1845, despite being absent from the parish for thirteen years. Becoming a cleric seems a strange choice for someone heavily involved in politics, and critical of the way the government operated. Making himself more unpopular, Arthur was a Chartist, who supported reform of Parliament and male suffrage.

Remembering the rioting in the Market Place in 1831 and 1832, he would have clashed with the earl. Possibly, this might have been why he sought and obtained permission to live outside his parish, although heart trouble was given as the official reason. If anyone thought it was the end of Arthur Wade, they were soon disappointed.

62

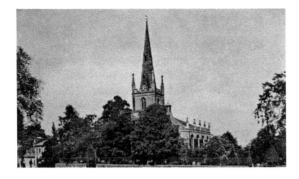

St Nicholas' Church.

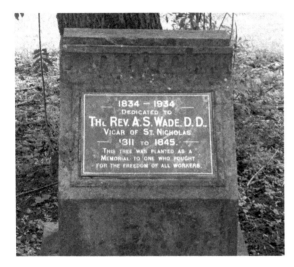

Wade plaque.

During continuous countrywide unrest, 1834 saw the case of the Tolpuddle Martyrs, who were six agricultural labourers, sentenced to transportation for swearing an oath when joining a trade union. It was a travesty of justice, and Arthur campaigned for their release, which the government rejected. Undeterred and still fighting, he became chaplain to the London trade unions, but the government banned him from preaching. Despite this setback he continued fighting for their release. They were pardoned in 1836 thanks to the efforts of radical Home Secretary Lord John Russell, who put pressure on William IV.

Meanwhile, Arthur returned to St Nicholas', where he was forcibly prevented from entering and conducting any services in his church – he had made too many enemies. Nevertheless, he continued his campaigning in support of the needs of the working class.

His health ultimately failed, and he died in 1845, but was not forgotten. In 1934, on the centenary of the Tolpuddle Martyrs, a willow tree was planted in St Nicholas' churchyard to his memory. Underneath a plaque reminds everyone how Arthur fought for 'the freedom of all workers'.

In 1819 Orator Henry Hunt passed through Warwick on his way to speak at what became known as the Peterloo Massacre. It is possible he might have spent some time with Arthur.

7. Buildings

St Mary's Collegiate Church

Today's church is largely post-fire rebuilding, but not without some problems in the process. Christopher Wren submitted plans for the project, which were not accepted. The successful architect, Sir William Wilson, planned the tower as an integral part of the church. Unfortunately, it was too heavy, and he asked for help, which came from two of Christopher Wren's master masons. Their remedy was simple, and the tower was built adjoining the main body of the church. The niches on it were part of the then fashionable building design and not intended to, and never have housed statues. Inside, the pillars by the west door show where they had cracked with the initial weight of the tower. There was some vandalism here in 1642 by the Puritans. Despite their edicts, bells were rung on Christmas Day 1655.

The famous Beauchamp Chapel, which escaped the fire, was paid for by Richard Beauchamp, the earl involved in the trials and execution of Joan of Arc. She was burnt alive at the stake for cross-dressing. Beauchamp did not come out of this episode well and building this chapel was probably his penance. Follow the eyes of his magnificent tomb effigy. They are focussed on a picture of the Virgin Mary on the ceiling. Is he saying sorry?

Among other tombs is the joint one of Robert Dudley and his second wife Lettice Knollys. She was hated by Elizabeth I, who made life difficult for the couple. Lettice had the last laugh by outliving them all, and her effigy on their joint tomb is higher than his!

Music and musicians are shown in some of the stained glass, where one man is playing a hurdy gurdy. This music is played occasionally at services. On leaving the chapel there is a doom painting over the exit, warning sinners of their fate if they did not live godly lives in future.

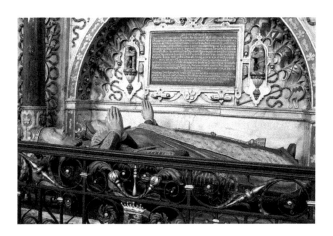

Joint tomb of Robert Dudley and Lettice Knollys.

The Court House

Situated at the corner of Castle Street and Jury Street is this magnificent post-fire building. Its vastly inferior predecessor housed the town council and escaped serious damage in the fire. When the town's reconstruction began, the councillors were so envious of the new buildings, they wanted one as well. They commissioned the building, now known as the Court House, being where the magistrates once sat. Not having sufficient funds to pay for it, they helped themselves to money from some of the town's charities, hoping their actions would not be discovered. It was a forlorn hope, and the council was placed into administration to repay these losses and were banned from the building until then. The ban included using it for entertainment purposes.

Following the failure of the 1715 Jacobite Rebellion, and continued anti-George I feelings in the country, a troop of dragoons was based here, during which they caused considerable damage. Consequently, the military was banned from being stationed there again, until 1914 when the Army Pay Corps moved a branch here.

Magistrates have not heard any cases here for many years, but it still retains its name. It remains the headquarters for Warwick Town Council and houses the visitor information centre. In non-Covid times, the ballroom is a popular venue for events.

After the 1906 Pageant, the council came into possession of the building adjoining the Court House, now known as Pageant House, with the Pageant Gardens situated behind. This was where the disgraced solicitor Kelynge Greenway had lived.

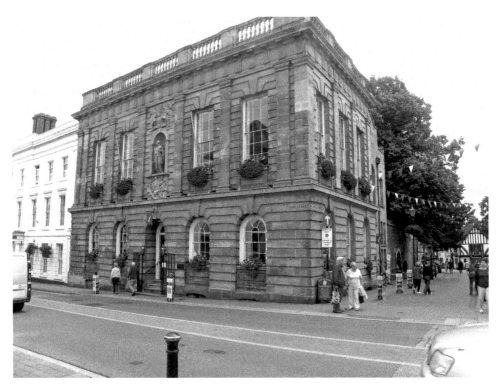

Court House.

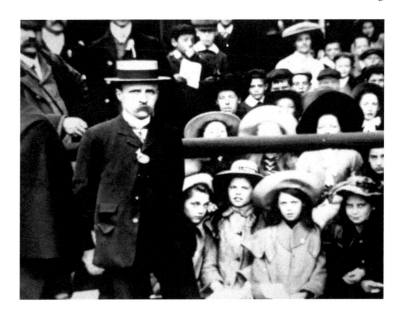

Warwick
Pageant, 1906.

Old Gasworks.

The Gasworks

Constructed in 1822, they stand in the Saltisford and are one of the first of this type of building in the world, with its two octagonal towers once holding the gasometers. These have been dismantled, the towers lowered and now converted into housing.

On 17 May 1941 two men were reported having been killed by a fall of earth on the nearby Common. In reality, they were killed by a German bomb, possibly aiming for the gasworks. Was this censorship at work again?

Guy's Cliffe House

These romantic-looking ruins, situated just outside Warwick, on the Coventry Road, are all that remain of the original old house. Following a chequered history, the house fell into disrepair after 1945. It is first recorded as a secluded place of worship originating in the fifth century, and later named after the legendary Guy of Warwick, about whose life there are various versions.

Guy was a squire to the earl, before the Norman Conquest, possibly in the tenth century, who fell in love with the earl's daughter, Felice. It was a mutually shared love, but this was a problem because of their social differences. The solution required Guy to go out and win his spurs, which he did and finally they were married. Guy, however, was unable to settle down and went on a pilgrimage. The years passed and he did not return. Believing him dead, Felice spent much of her time caring for hermits in the area known as Guy's Cliff.

One day she received a ring from another hermit, which she recognised as Guy's, and suddenly realised he was one of the hermits she had cared for over the years, not knowing it was him. Their reunion was short lived, and Guy died in her arms. Felice died soon afterwards. Some say of a broken heart whilst others believe she took her own life by jumping in the Avon. There is some disagreement between experts as to where Guy was buried – here or in France?

Guy may have contracted leprosy whilst he was away, hence his becoming a hermit. The author once took an American professor, who was a specialist in English literature,

Guy's Cliffe House.

Guy's statue.

to the house. She believed Guy could have been a role model for the Green Knight, from King Arthur's Knights of the Round Table.

Between Warwick and Guy's Cliffe, there is a statue commemorating Guy slaying the Dun Cow. She was a large, ferocious beast who roamed the Warwickshire countryside and bears no resemblance to the spindly creature in the statue.

In 1773, lady's maid Sarah Kemble eloped from here and became the actress Sarah Siddons. It was not easy, and she worked hard to achieve her fame. Years later, she regularly visited her former employers, with the earl being one of her many admirers.

During the First World War, the house became a military hospital, where Nurse Janet Mary Greatrex, from Ashbourne, Derbyshire, died, and is remembered on Warwick's War Memorial.

During the Second World War, it doubled up as a school and hospital, before being sold in 1946. Since then, failing to become a hotel led to the roof and floorboards being stripped, now leaving a ruin owned by the Freemasons.

There was a fire here in 1992 where the *Last Vampyre* tale, based on the Sherlock Holmes story the *Sussex Vampire*, starring Jeremy Brett, was partly filmed. This location was chosen for its ruins, which were needed for a fire scene. Unfortunately, the fire caused more damage than planned. The insurance claim was settled, with the strict proviso the money was to be spent returning the house to its ruined state, and not for other repairs.

The Leper Hospital Master's House

This building, in the Saltisford, usually referred to as the Leper Hospital, has been neglected for more than fifty years to the author's knowledge. Founded in 1135, it became a leper hospital in 1275 for a short time and is now in ruins. Some renovation has been

Leper Hospital Master's House.

carried out on the nearby chapel, but to quote the English Heritage Buildings at Risk Register, its condition is 'very bad'. At one stage it was St Mary's poor house.

During the 1970s, the earl offered to restore and re-erect it in the castle grounds, but it never happened. It currently remains under wraps, heavily supported to prevent its total destruction. In 2021, a compulsory purchase order was served on the owners, with plans being considered to turn it and the surrounding area into housing. The owners objected to this order, but they have been overruled.

The Lord Leycester Hospital

Undoubtedly the oldest collection of buildings in Warwick, with parts going back to the twelfth century. Prior to the Reformation, it housed the town's religious guilds. In 1571, Robert Dudley, Earl of Leicester, appeared seeking a home for twelve retired or injured soldiers, known as brethren, and their wives, and he settled on these buildings. Bearing in mind his connections with Queen Elizabeth I, and the then earl was his brother, the occupiers of the building knew they had to go.

Unfortunately, there was a mix-up over the dates when Dudley arrived to take possession, and there was nobody to welcome him and his friends. He kept Warwick's chief burgesses and citizens waiting in the pouring rain and contemplated cancelling the deal, before accepting their apologies. Hospital here means hospice or hostel and still houses ex-services personnel. James I visited in 1617 and neglected to pay the bill for himself, staff and courtiers. It took ten years to pay it.

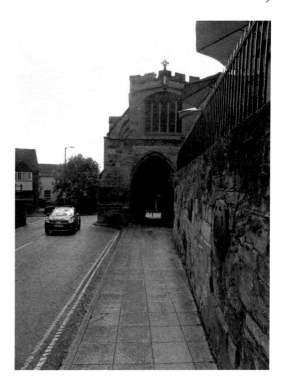

Westgate.

The site includes the Chapel of St James, situated over the Westgate, which only has one electric socket, meaning night-time services are all candlelit. Whilst atmospheric, it can be rather cold in winter. The chapel was extensively restored by Sir George Gilbert Scott in 1860. Over the door is a stained-glass window created by William Morris, who also designed the hangings around the altar.

This old western entrance into the town, known as the hanging gate in the Middle Ages, was where malefactors were hanged. Locations, such as entrances into towns, were deliberately chosen for punishment sites, as a warning to visitors, showing what would happen to them if they broke the law. During the Second World War, it was used as an air-raid shelter, known as the Maze, and subject of complaints about it being used for immoral purposes!

Just outside the arch is another Trollope pillar box. The supporting wall on the right on the town side of the arch, in High Street, was severely damaged by floods and rebuilt some years ago. Its support roundels show the Warwickshire Bear and Ragged Staff, complete with chains and muzzle, coat of arms of the earls, who allowed the county council and other bodies to use it in 1889. Various tales surround the origins of the earl's coat of arms, but it was a simple marriage between two families and a merging of their coats of arms: a bear and a ragged staff and later chains and muzzle.

Following controversy some years ago, the chains and muzzles were removed from most of the bears after complaints about it being cruel. In fact, an earl was ordered to paint chains and the muzzle on the bear, by royal edict, 'to show the world how the power of the earl had been muzzled by the king'.

Roundel.

Oken's House

Now tearooms situated in Castle Street, they once belonged to Thomas Oken, who undoubtedly deserves the reputation of being Warwick's 'most famous son'. Probably born during the reign of Henry VII, he died in 1573. Thomas was a survivor, being a Roman Catholic in an often Protestant country. Not much is known about his early life, but he was the Religious Guilds Master at what would become the Lord Leycester Hospital. One result of Henry VIII's conversion to Protestantism was the seizure of Catholic assets, including premises such as the guildhall. Thomas prevented this happening, along with his personal assets, which were carefully invested, and still provide a considerable income today (2022). It was some of his money which was misappropriated to build the Court House.

His 'pious wife Joan' predeceased him, and they were childless. Approaching death, Thomas willed most of his assets to friends. A second will quickly followed, which left most of his assets to the town, instead of to them. The friends tried, unsuccessfully, to make him revert to the first will. A dispute arose after his death in which Sir Thomas Lucy, of Shakespeare fame, adjudicated and found in favour of the second will.

Over the years the building has had many uses including an antique shop and between 1955 and 1987 was a doll's museum, which Joy Robinson, a passionate collector of dolls, created. Her collection now belongs to the Warwickshire County Museum Service. Some dolls were once reported stolen, but, luckily, they had only been mislaid and were soon found.

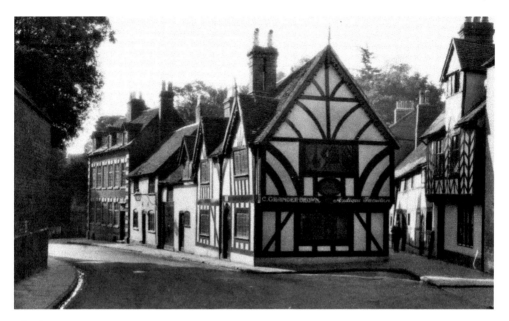

Oken's House.

Dolls Museum.

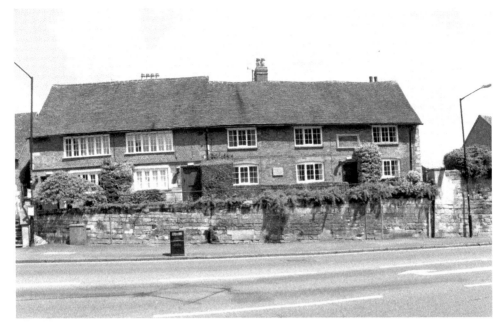

Almshouses.

Today, Thomas is remembered for the two charities: the first is Henry VIII Charity, fondly known as Uncle Henry, and the second is the Charity of Thomas Oken and Nicholas Eyffler, whose almshouses include those on Castle Hill. They are high up because the road was significantly lowered in the eighteenth century. Thomas provided money for an annual feast to be held in his name. The event still happens, although attendees pay much more for their meals than the original 6*d* it cost. When the author was Beadle, he was paid £20 annually by the charity for clearing up after the weekly market, but happily left this job to the appropriate authorities.

No. 3 High Street

Its outstanding feature is the Egyptian-style carved wooden porch, created by local carver Thomas Henry Kendall (1837–1919), and is a listed building. During the 1970s it was a Chinese restaurant, whose owners decided to paint all the front brickwork white, without any form of planning permission. Soon afterwards they moved away. The new owners spent time and money restoring the building by either cleaning the bricks or turning them round to hide the painted parts. They later moved into other premises and the building has had several different owners since then.

The Porridge Pot

These once popular tearooms, in Jury Street, with a long history of catering, are now a pizza house. Its original name is reinforced by an old porridge pot hanging up as a sign. When it was sold and became the first of several pizza houses, the new owners took down the porridge pot. Unfortunately for them, it was listed and had to be returned.

Right: No. 3 High Street.

Below: Porridge Pot.

8. Writers

Various writers have either lived in or visited Warwick. Below are some of them.

Victoria Eleanor Louise Doorly

Preferring to be known as Eleanor, she was born in 1880. Following her father's premature death, she moved from Jamaica to her aunt in Leamington. She went to the Kingsley School with further education in France and London. Influenced by the views of the educational pioneer Mary Buss, she put her mark on teaching in 1922, when appointed headmistress at Kings High School for Girls, in Smith Street. Despite a busy schedule at school, she chaired the 1930 Pageant Introductory Committee and arranged lecture programmes given by a host of well-known people.

1930 Pageant.

Eleanor was ahead of her time in forming a Parent Teacher Association and Class and School Councils, which continue today. In school, she liked to be called 'Aunt Do', preferring the pupils to think of her as such and not as head teacher. Her faithful companion, for several years, was an Alsatian dog called Vlah, which is Albanian for friendship. Although Eleanor encouraged her pupils to go to university, she did not want blue stockings. Despite many sexist criticisms, she was adamant girls could be wives, mothers and have careers. Unlike some other educational organisations, she let her pupils help the war effort by working on farms.

A prolific writer of children's books, she was best known for *The Radium Woman.* It was about Marie Curie, published in 1939, and won her the Carnegie Medal. Following her retirement, she wrote two more books before dying at Dartmouth in 1950.

Robert Eyres Landor
Always overshadowed by his older brother Walter (see below), and not as controversial, Robert became a good writer. Born in 1781, he was educated at Bromsgrove and went into the Church. Despite his literary skills, he was not always recognised as a writer. He sometimes checked his brother's grammar.

Walter Savage Landor
Robert's older brother was Savage by name and savage by nature, which ensured he disagreed with countless people throughout his life. Born in 1775, he had the advantage of having wealthy parents. He was educated at Knowle, then Rugby, where he became very proficient at Latin. It was not long before he was in trouble for insulting the headmaster. His next move was to Trinity College, Oxford, causing more trouble on the way, including shooting up the house of a Tory sympathiser. This was too much for his father and following a massive quarrel, Walter left home, which is currently in a sorry state.

He lived for a while in Spain, helping their fight against Napoleon, but soon came home. His next venture was as a landowner in Wales, until his money ran out. Forgetting his good intentions, he soon antagonised the locals with his tantrums, abandoned the project in 1813 and moved to Italy. After an unhappy marriage, he left his family there and returned to England. During his life, Walter produced numerous literary works looking at contemporary and historical figures, albeit not always in a good light. Becoming friends with Charles James Fox, thanks to Samuel Parr, he wrote several political attacks on the government. He loathed the Hanoverians and wrote uncomplimentary verse about them:

> George the First was always reckoned
> vile, but viler was George the Second
> And what mortal ever heard
> Any good of George the Third?
> But when from earth the Fourth descend
> God be praised the Georges End.

Landor House.

Never being one to shrink from controversy, he wrote articles in Latin that bordered on being libellous, if they could be understood. It worked well as a defence, but not in Italy! After a brief reunion with his wife he moved to Florence where he died in 1864.

Amongst his literary friends was Charles Dickens, whom he met in 1840. The following year he became godfather to one of his sons and attended the christening party. Landor had impressed Dickens so much that his son was named Walter Savage Landor Dickens.

John Masefield

Born at Ledbury in 1878, John was sent away to Warwick school, which he hated. Less than ten years old, he found life at a boarding school difficult at first. Undoubtedly, he was bullied once his tormentors discovered he wrote poetry. Finding the bullying too much, he tried to take his own life by eating laurel leaves, which only succeeded in making him ill.

Another time he ran away but was found by a police officer and returned to the school, where he was flogged. Everything changed when a new junior part of the school was opened, which operated a less harsh regime, and John enjoyed the rest of his time there. Many of his later writings defended the weak against the strong, following his experiences at school.

Aged just thirteen, he left school and joined the merchant sea service. Forced to leave the sea because of ill-health, he began writing in earnest. He wrote a mixture of

plays, histories and children's books, but is best remembered for his poetry, especially 'Sea Fever', not forgetting 'The Nine Days Wonder', saluting the men who escaped from Dunkirk. Appointed Poet Laureate in 1930, he held the position until his death in 1967.

Philip Arthur Larkin

Originally from Coventry, where he was born in 1922, Philip's family moved to Warwick to escape the blitz in 1941. He was unfit for military service because of poor eyesight. Whilst in Warwick, he regularly drank at the Crown, at the junction of Coten End and Coventry Road, now called the Castle Limes Hotel. This picture includes part of the Motor Panels Shakespeare Run, c. 1990.

Leaving home in 1943, he ultimately became librarian at the Brynmor Library of the University in Hull from 1955 to 85. Later known as the 'Hermit of Hull', he became a prolific writer. Although he never married, Philip was not averse to female company. An agnostic, he was described as being 'grumpy and glum', moods that are often reflected in his poetry. Numerous honours were bestowed on him, and he was offered the post of Poet Laureate in 1984, which he declined, and died the following year.

John Ronald Reuel Tolkien

One of England's most famous authors, Tolkien is remembered here. Born to German parents in South Africa in 1892, he came to England four years later with his Roman Catholic mother. When she died, the young Tolkien was taken into the care of the Roman Catholic Church in Birmingham. Imagine their horror when he fell in love with Edith Mary Bratt, who was not only older than him but also a Protestant. Hoping to end their association, the Church banned him from communicating with her until he was twenty-one. Just days after reaching his majority, he proposed to her.

Crown Hotel.

St Mary Immaculate Roman Catholic Church.

She agreed and converted to Catholicism, which offended her landlord so much, he evicted her. Edith moved to Warwick, where the couple married at St Mary Immaculate Roman Catholic Church, West Street, in 1916. Being an officer in the Lancashire Fusiliers, he was posted to France and fought on the Somme. After contracting trench fever, he was returned home and finally demobilised in 1920.

Already possessing a First-Class Honours Degree in English Language and Literature from Oxford, he returned and taught there until retiring in 1959. Meanwhile his writing career took off and he is well remembered for his Hobbit novels. He found fame a double-edged sword, as it gave him no peace and interfered with their lives. Edith died in 1971, and he followed her twenty-one months later. They are buried together at Wolvercote Cemetery, Oxford.

Tolkien loved Warwickshire, having lived in the county, close to Birmingham, during the early part of his life. It is believed Warwickshire became the model for the Shire in his novels.

Mark Twain
Samuel Longhorne Clements, to give him his proper name, may or may not have visited Warwick. He definitely went to Stratford and quite possibly came here for a visit. In 1884 he started his novel *A Connecticut Yankee at King Arthur's Court,* which appeared five years later. The story is about an American tourist, staying at the Warwick Arms, meeting

fellow countryman Hank Morgan, an engineer, at the castle. Morgan related an amazing story of time travel from the nineteenth century back to the court of King Arthur. After several adventures, Hank applied his late nineteenth century technology into the world, where he then lived, before returning to the present day.

He created gunpowder, revolvers and gatling guns to name but a few products, making numerous enemies on the way, including Merlin, who finally overpowered him. Hank is sentenced to sleep for 1,300 years, and on waking, he met the tourist in Warwick Castle, and later at the Warwick Arms where he dies. The story's narrator was Mark Twain.

Despite its setting, Twain wrote the story in Missouri. Despite being a sci-fi genre, it included excerpts from Mallory's *Morte d'Arthur*. Readers either like or loathe its witty satirical writing. Having been born when Halley's Comet was visible, Twain always maintained he would die when it reappeared. His death was recorded in 1910, the day after the Comet was at its closest point to Earth.

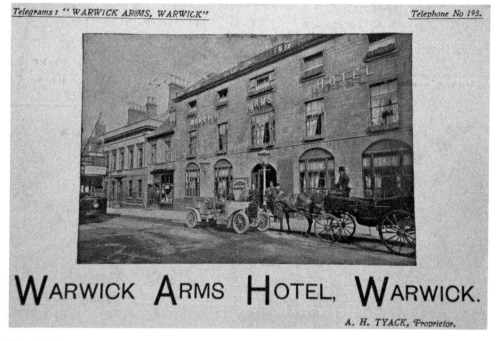

Warwick Arms.

9. Social

Court Leet

Warwick has one of fewer than fifty courts leet still functioning in England. There are another two in Warwickshire – Alcester and Henley-in-Arden – with a third at Bromsgrove in Worcestershire. The others are located elsewhere in the country. Court is the usual meaning of the word, and Leet means a territorial or jurisdictional area, possibly deriving its name from the Anglo-Saxon word 'Leete'.

Originating during the thirteenth century as an extension of the manor courts, these bodies prosecuted minor offences. The court's jurors, still known as such today, acted as witnesses, investigators, indicted wrongdoers and helped to decide on punishments. It was not a trial by jury, and many of their roles were gradually replaced by magistrates. They then became more proactive in what is best described as trading standards and public health capacities. Whilst court leets have no legal powers today, they help promote their local areas and traditions.

Warwick's court was first recorded in 1554, and has remained ever since, although some people believe it originated earlier. Warwick's jurors have been dual gendered for many years, and only the steward, who is also the town clerk, holds a permanent position. Other officers are subject to an annual re-election. All its members are robed and wear medallions signifying their membership and roles they perform, such as bread weigher, fish and flesh taster, overseer of buildings, etc.

The court is totally self-funding and uses no public money. Guests attending any of its functions either pay for themselves or are treated by their hosts. It is a similar arrangement when attending other courts. Likewise, when visiting retail premises or public houses, everything is paid for by the court.

Their main duties today are to support the mayor, who is also the Lord of the Leet, and town council at civic and other important events. The court receives and hears presentments from residents about issues they may have in the town. These are discussed, and where possible action is taken, usually referring the matter to the appropriate authority.

Once a year (Covid permitting), the court holds an Assize of Bread and Ale, during which selected retail premises are visited, their products sampled and commented upon with due ceremony, under the control of the bailiff aided by the town crier. Subject to the products being satisfactory, the owner or licensee receives a certificate, properly authenticated with a seal, to display in their premises. The Ale Taster's role is the most coveted position, which the author has held for many years, and has no intention of retiring from just yet. When officially tasting the brew, the ale conner, to use the old title, checks and comments on its temperature, head, clarity, nose and taste. Subject to favourable comments, certificates and sprigs of evergreen are handed over to the

Court leet ale tasting.

establishment. The sprig is a relic from the time before inn signs, when hostelries were marked by boughs or wreaths of greenery. In addition to this particular day, twice a year an official ale tasting ceremony is held at various establishments.

Twice a year (Covid permitting), the court holds a beer festival. This picture shows the then bailiff Maureen Sutherland and past bailiff Michael Honnoraty in attendance. The first raises much needed money for the Lord Leycester Hospital, in addition to the previously supplied floodlights whilst the second provides funds for local organisations, such as Myton Hospice, Warwick Words, Christmas lights for the town and other deserving causes. Another court activity is running the popular annual classic car show in the Market Place.

Alternate years, the court runs a Town Crier's Competition, which is a colourful and noisy event, including a parade through the town, with the actual competition happening in the Pageant Gardens. Being close to the Registry Office, some wedding photos have town criers in them.

In 2018, several court members visited the Menin Gate at Ypres. Here the bailiff laid a wreath to the memory of all fallen First World War personnel with Warwickshire connections, who are recorded there. Whilst the bailiff and past bailiffs Michael Honnoraty and Tony Hemming were waiting their turn, they spoke to the group behind them only to discover they were pupils from a school from neighbouring Leamington Spa. During the same year, they purchased a transparent silhouette of a soldier from the First World War era, now known as Tommy, for the town.

Beer Festival.

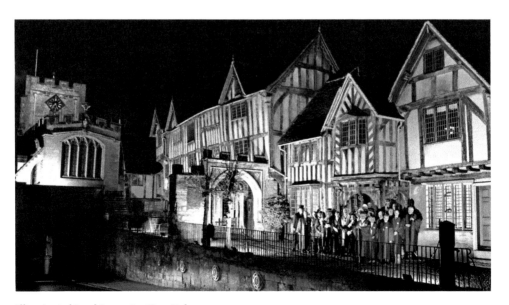

Illuminated Lord Leycester Hospital.

Town Crying
Competition.

Menin
Gate, Ypres,
Belgium.

Tommy.

Food and Drink

It was believed in 1814, albeit erroneously, that Napoleon had finally been defeated and was imprisoned on the Isle of Elba. A committee of local dignitaries organised a huge celebration for 4 August on the Common. Participants brought their own cutlery, plates and mugs. An estimated 6,000 people sat down to the meal where 6,300 lbs of beef. 1.5 tons of pudding containing approximately 2,000 eggs, and 4–5,000 gallons of stingo (strong beer) were consumed. They occupied twelve tables, each 120 yards long. The Reverend Arthur Savage Wade said grace. All shops closed at noon and various entertainments took place. The upper class took no chances and left before the event terminated at 10 p.m. in case it became too rowdy for them. Among the many toasts drunk was one to the abolition of slavery all over the world.

Sadly, it was a premature celebration because Napoleon escaped, and Europe returned to war before his final defeat at Waterloo in 1815. There were no celebrations then. A similar event in 1919, marking the actual end of the First World War, not the Armistice, was a low-key affair, because there were too many bereaved families in Warwick. 1945 saw numerous street parties at the end of the Second World War.

An ingenious fraud was committed in 1816 by a man selling 'Smuggled Brandy'. He drilled into a barrel, in front of hopeful customers, and withdrew a small genuine measure of brandy. People tasted and liked it, then purchased some barrels. By the time they realised the only genuine brandy had come from a carefully inserted small phial in the barrel, from which the sample was taken, the remainder being water, the conman had left.

The poor were not forgotten, and in hard times, especially following the Napoleonic War, soup was provided by the town's parishes on certain days of the week. People were urged to restrain their consumption of bread and flour because corn prices were high. 'Total abstention from pastry was recommended.'

Local auctioneer John Margetts sold the effects belonging to the late Mrs Hall from the Warwick Arms in 1818. In addition to various animals, harness etc., the sale included several sets of blue and white dinner services, 2,400 glass bottles, several iron-bound casks with capacities from 2–365 gallons, and saucepans of 'every size'.

Food adulteration is nothing new and general warnings were issued in 1818 about bread being made with flour, chalk, ground stone and pulverised bones. Coffee was made from scorched peas and beans.

In 1900, more than 6,000 people were poisoned nationwide by arsenic tainted beer, including many in the Midlands. At least seventy people died as a result of drinking it. It was not thought any came from Warwick.

The Coffee Tavern, Old Square, is a strange name for a public house, but it was once a temperance hotel. During the late 1800s, a swing towards temperance created a growth in buildings catering for these needs, but they were usually unsuccessful. Many were run by failed workhouse keepers and premises quickly acquired bad reputations. The Coffee Tavern, built in the 1880s, was what its name suggests, before becoming offices at some stage. It recently became a public house but kept its original name. One of its early staff was a former cancan dancer.

Old Coffee Tavern, *c.* 2000.

Health

Remedies for animal, and human complaints, were sold in various premises, not just pharmacies. For instance, in 1819, printer Henry Sharpe sold Wainwrights Staffordshire Cordial English Medicine for Horses. He also sold Mr Lignum's Pills, recommended for 'the infallible cure of all degrees of syphilis diseases. One box would convince the patient of his recovery'.

Anthrax was a serious problem when handling animal skins, and the early treatment for such infection was to pour a kettle of boiling water over the affected area. The author remembers in the 1950s the piles of animal skins deposited in Nelson Lane and destined for the Nelson gelatine works. The stench was vile.

Castle Hill Toilets, as their names suggest, were once public conveniences built into the castle wall and grounds, but closed many years ago. Confusingly, the names of 'men' and 'women' remain. During the Second World War, Castle Hill was the regular meeting place for local girls and visiting troops. The local hunt met here on Boxing Day in the 1950s.

There was a serious outbreak of cholera in 1849, which led to a Board of Health report. Unsurprisingly, it found the water was contaminated and fresh supplies were to be obtained elsewhere. Water for drinking, washing, waste and animal uses all came from the same source. At least 10 per cent of the population was rated as poor.

Nelson Lane.

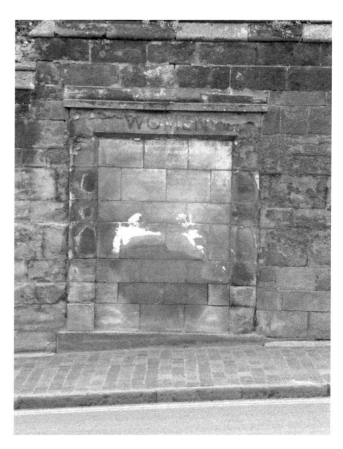

Castle Hill.

Travelling doctors and eye specialists, to name but two, visited towns to carry out their work. Warwick was no exception and regular notices advised when and where they could be seen. The Warwick Arms was a popular venue, and in 1813 a London oculist saw more than fifty patients, allegedly curing blindness in some of them. Other doctors had their own practices in the town, one being Walter Savage Landor's father, in Smith Street. Another was William Lambe, who practiced for a short time with Walter's father. He is sometimes called the 'father of veganism'.

Dentists became more common in nineteenth century, and the dental practice in the Old Square has been in situ for many years. It sports a beautiful stained-glass window, which is believed to be Victorian, but no records exist about it.

A miraculous recovery occurred during 1809. An unnamed young woman had lost the use of her legs for no apparent reason two years earlier and no cure had been found. Suddenly one evening she experienced a considerable amount of pain in her legs and found she could walk again.

Rabies was taken very seriously, especially with numerous dogs roaming the town. Following a scare in 1808, when eleven people were bitten by a supposed mad dog, the mayor ordered any animals found at large to be destroyed. Dog owners would be assessed for paying extra taxes. Poor people with dogs could no longer obtain any parish relief. The recommended medical treatment was to open up the wound and administer caustic soda.

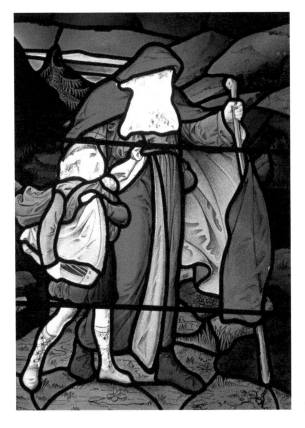

Dentist's stained-glass window.

Zetland Arms.

In early 1809, the Reverend Field's dog suddenly bit at least two people, along with other animals, and the mayor's earlier notice was repeated. The problem recurred over the years and stray dogs were destroyed, whether rabid or not. What would the mayor have thought about Casey from the Zetland Arms, Church Street, in the 1970s? Casey was a Golden Retriever and self-appointed quality controller of bones from the town's butchers. He visited them most days, collected a bone, returned home and lay sampling it by the front door. When he died, the *Warwick Advertiser* printed his picture and gave him an obituary beginning: 'One of Warwick's best known residents died this week...'

Smallpox was rife during 1806 and cow pox vaccinations were given at St Mary's parish workhouse on Tuesdays and Fridays for six weeks. The vaccine had only been in existence ten years.

Spanish Flu hit Warwick in the aftermath of the First World War. With no cure available, sufferers lived or died. There are no official figures for Warwick, but approximately 24,000 people died from it in Warwickshire. Preventive advice included gargling or even swallowing diluted Jeyes fluid. Just over 100 years later, the world is fighting another pandemic.

Miscellaneous

Located in Castle Lane, the Face is on the rear wall of one of the houses in Eastgate Mews, a group of more modern buildings at the rear of Eastgate House. Their garden walls are of old sandstone and back onto Castle Lane. Whilst the walls are owned by the Castle, the houseowners are responsible for their upkeep, and stonemasons can be difficult to find. Unfortunately, until they have weathered, new stonework can resemble breeze blocks. This well weathered face is believed to have come from a dismantled chapel in the castle grounds and inserted here, probably when the earl extended his grounds and moved Castle Lane outwards.

Cobblestones in Castle Lane are the last remains of the road out of Warwick, leading down to the old bridge over the Avon, which was blocked off during the earl's extension plans.

Castle Lane face.

Castle Lane cobbles.

Royalty

When George III celebrated reigning for fifty years, the council agreed not to have fireworks, illuminations and anything else which 'may tend to lead to the Subversion of the Good Order and Peace of the Inhabitants and occasion unnecessary expence [sic]'.

In 1819, the then popular Prince Regent, later George IV, visited the earl, resulting in many buildings displaying illuminated transparencies, including one at the Warwick Arms, described as 'the portly figure of John Bull'.

George's popularity soon waned because of the way he ill-treated Queen Caroline. Their marriage was a disaster, and she lived abroad. On returning to England to take up her role as queen, he tried to divorce her. The collapse of the trial led to countrywide celebrations. Church bells were rung at intervals for several days and buildings displayed coloured lamps, often clustered to make the letters C R (Caroline Regina). In St Nicholas' parish, residents burned effigies of him, having first paraded them around the town. George banned her from his coronation, and she died in 1821. Yet, celebrations happened in 1821 for his coronation, with the usual illuminations in large numbers, without any mishaps, despite being discouraged as a fire risk. Two oxen were slaughtered, roasted in the Market Place and given to the poor.

When Queen Victoria was crowned in 1838, it was another excuse for celebrations, with more than 5,000 people dining in the Court House and Racecourse. In 1901 news of her death first arrived via a telegram to the earl. On 22 January, the mayor read a proclamation for Edward VII in the Market Place in pouring rain. Public houses were closed and police wore black armbands as a mark of respect.

Tink-a-tank

This is the fascinating name given to the walled footpath leading from St Mary's churchyard to the Butts. Whilst the path's purpose is obvious; its name is not. Going towards the Butts, on the left are the College Gardens, which once housed a school. One suggestion is the name goes back to the time when the footpath was flagged, and not as it is today. When the boys ran through here, the sound of their hob-nailed boots made a 'tink-a-tank sound'. Another suggestion is the noise was made by the metal pattens ladies wore on their shoes, to keep their dress hems out of the mud, making a similar sound.

A vicar told the author he believed 'tink-a-tank' is a corruption of 'think and thank God', which is a reason for going to church. Or it may have come from the echoing sounds of the church bells. 'Tink-a-tanks' are often found near churches but not always.

Tink-a-tank, the Butts entrance.

Town Crier's Visit to Warwick School

An unusual custom involves the town crier making an annual visit to Warwick School, believed to be the oldest boys' school in the country, created during the reign of Edward the Confessor (1042–66). The school moved to its present site in the late nineteenth century.

Custom dictates the crier addresses the assembled pupils and staff on behalf of the mayor and asks for them to be 'given an extra half day's respite from their labours'. The crier is taken to the headmaster to make the request, which is granted, and the pupils are informed of the decision.

Once when the author was town crier, he put the request to the headmaster, who, much to everybody's surprise, declined to agree. Struggling to keep a straight face, he explained they would get an extra week at half-term instead. The author returned to the assembly with a long face and explained how the head had rejected the request. There was total silence for several seconds before the booing started. Once he explained about the extra week at half-term, the boos changed to cheers. This picture has the crier reading the request around 1987.

Annual visit of town crier to Warwick School.

Bibliography and Further Reading

Abercrombie Patrick & Nickson Richard, *Warwick Its Preservation & Redevelopment* (The Architectural Press, 1949)

Bolitho, Paul, *Ripples from Warwickshire's Past* (Warwickshire Books, 1992)

Bolitho, Paul, *More Ripples from Warwickshire's Past* (Warwick: The Warwick Printing Company Ltd, 1997)

Bolitho, Paul, *Warwick's Most Famous Son* (The Charity of Thomas Oken and Nicholas Eyffler, 2003)

Brindley, David, *Richard Beauchamp, Medieval England's Greatest Knight* (Tempus Publishing, 2001)

Eddleston, John J., *The Encyclopaedia of Executions* (London: John Blake Publishing, 2002)

Field, William, *The Town and Castle of Warwick* (republished by S. R. Publishers Ltd, 1969. Originally published by H. Sharpe, 1815)

Hadfield, Charles, *The Canal Age* (David & Charles, 1968)

Jennings, Allan, & Coulls, Peter, *The Leamington and Warwick Tramway* (Syndi Books, 2019)

Kemp, Thomas, *A History of Warwick and its People* (India: Pravana Books India Classic Reprints, 1898)

Kemp, Thomas, *The Black Book of Warwick* (transcribed by Henry Cooke & Son, 1898)

National Union of Teachers, *The Tolpuddle Martyrs* (Trades Union Congress, 2000)

Palmer, Roy, *The Folklore of Warwickshire* (B. T. Batsford, 1976)

Pitt, Charles, *Chandler's Leap and other stories from Warwick Racecourse* (Weatherbys, 2019)

Powell, J. A., *Fire-Fighting in Warwick* (Warwickshire Local History Society Occasional paper No. 8, 2001)

Rommelare, Guy, *The Forgotten Massacre* (Warwick: Warwick Printing, 2001)

Sutherland, Graham, *Bloody British History Warwick,* (The History Press, 2013)

Sutherland, Graham, *Warwick at War 1939–45* (Barnsley: Pen & Sword, 2020)

Sutherland, Graham, *Warwick in the Great War* (Barnsley: Pen & Sword, 2017)

Warwick and Warwickshire Advertiser, various dates

Warwickshire Police Corporate Communications Department, 150th Anniversary 1857–2007 of Warwickshire Police

Wilkinson, Frederick, *Those Entrusted with Arms* (Greenhill Books, 2002)

Acknowledgements

The author and publisher would like to thank the following people/organisations for permission to use the following pictures:

Firmstone
36. Exterior, New Street.
37. Interior, New Street.
Fletcher, Gill
93. Court leet ale tasting.
95. Illuminated Lord Leycester Hospital.
Fuller, Graham
14. Virginia House, Richmond, Virginia, USA.
Hill Close Gardens
49. Overview.
Old Square Dental Practice
102. Stained-glass window.
Saffron Walden Museum, Essex
46. George Wombwell's Wallace, Saffron Walden Museum, Essex.
St Mary's Collegiate Church
23. Ducking stool, St Mary's Church.
33. Entrance to The Royal Warwickshire Regimental Chapel, St Mary's Church.
34. Viscount Montgomery of Alamein's Banner, St Mary's Church.
74. Tomb of Robert Dudley and Lettice Knollys, Beauchamp Chapel, St Mary's Church.
St Mary Immaculate Roman Catholic Church
91. Marriage between John Ronald Ruel Tolkien and Edith Bratt, 1916.
Skinner, David
10. Old Fire Station, the Butts, *c.* 1920.
Smith, Mark
58. *Royal Scot.*
Sumner, Peter
4. Warwick's last Police Station, Priory Road, 1996.
Trustees of the Warwickshire Yeomanry Museum, Warwick
39. Gun captured from Turks at Huj, 1917, Warwickshire Yeomanry Museum, Castle Street.
Unitt, David
41. Venetian Fête programme, St Nicholas Park.
Warwick School

106. Annual visit of town crier to Warwick School, Myton Road.

Warwick Visitor Centre

63. Model of Tram Crash, Eastgate, 1916, Warwick Visitor Centre, Jury Street.

Warwickshire Constabulary History Society

6. Chief Constable Kemble with special constable and Duke of Kent, Northgate Street, 1934.

9. Crime Prevention display, Smith Street, 1950s.

21. Judge's procession, Northgate Street, 1930s.

76. 1906 Warwick Pageant.

Wing, Andy

27. German prisoner of war card, Racecourse.

The remaining pictures are from the author's collection. Every attempt has been made to seek permission for copyright material used in this edition. However, if we have inadvertently used copyright material without permission/acknowledgement, we apologise and will make the necessary correction at the first opportunity.